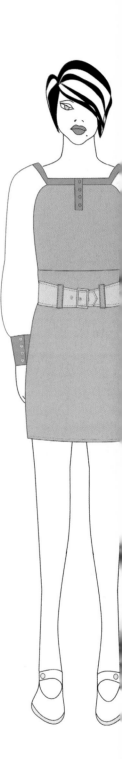

The Fashion Designer's
D I R E C T O R Y
of Shape and Form

SIMON TRAVERS-SPENCER
ZARIDA ZAMAN

A QUARTO BOOK

First published 2008
A&C Black Publishers
38 Soho Square
London W1D 3HB
www.acblack.com

ISBN 978 0 7136 8796 5

QUAR.FDD

Project editor: Rachel Mills
Art director: Caroline Guest
Art editor: Julie Joubinaux
Designer: James Lawrence
Design assistant: Jessica Wilson
Photographers: Stephen Ambrose and
 Paul Forrester
Illustrators: Kuo Kang Chen and
 Simon Travers-Spencer
Picture research: Claudia Tate

Creative director: Moira Clinch
Publisher: Paul Carslake

Manufactured in Hong Kong by
 Modern Age Repro House Limited
Printed in China by 1010 Printing
 International Limited

CONTENTS

Authors' forewords	6
About this book	8
How to use the figure on the fold-out flap	9

Chapter 1: The Design Process 10

An overview	12
Research	14
Moodboards	16
Design development	18
Working on a dress stand	20
Understanding proportions	24
Defining silhouette	26
Choosing colours	30
Finding your colour story	32
The whole process	34

Chapter 2: Directory of Shapes 38

Sleeves 40

Coat and jacket sleeves	42
Long-sleeved tops	46
Short-sleeved and sleeveless tops	48
Dress sleeves	50
Knitwear sleeves	52

Necklines and Collars 54

Coat and jacket necklines and collars	58
Shirt and blouse necklines and collars	62
Top necklines and collars	64
Dress necklines and collars	70
Knitwear necklines and collars	72

Waistbands	**76**
Short and trouser waistbands	78
Skirt waistbands	82
Pockets	**84**
Coat and jacket pockets	86
Shirt and blouse pockets	88
Short and trouser pockets	90
Skirt pockets	92
Cuffs	**94**
Coat and jacket cuffs	96
Shirt and blouse cuffs	98
Top cuffs	100
Knitwear cuffs	102
Fastenings	**104**
Coat and jacket fastenings	106
Shirt and blouse fastenings	108
Short and trouser fastenings	110
Hems	**112**
Coat and jacket hems	114
Short and trouser hems	116
Skirt hems	118
Dress hems	120
Knitwear hems	122
Chapter 3: The Textile Directory	**124**
Woven	127
Openweave	133
Sheer	134
Stretch	136

Resources	138
Index	141
Credits	144

FOREWORDS

From the very practical to the more fantastic of designs, I have always found immense satisfaction in cutting textiles and creating garments that will fit to the body and allow a person to express (or hide) their identity and individuality. In a world becoming more and more virtual, fashion design provides me with a context for creating wearable products that directly interact with people on a visual, textural and emotional level.

Fashion design is a rewarding discipline that continually tests and challenges. It is important to remember that the skills called upon in designing a fashion collection require imagination, creativity and originality, as well as the ability to sketch, pattern draft and sew. I hope that within the pages of this book, you will find information and inspiration that will guide you through this process and provide a catalyst for your ideas and designs.

The Fashion Designer's
D I R E C T O R Y
of Shape and Form

7206

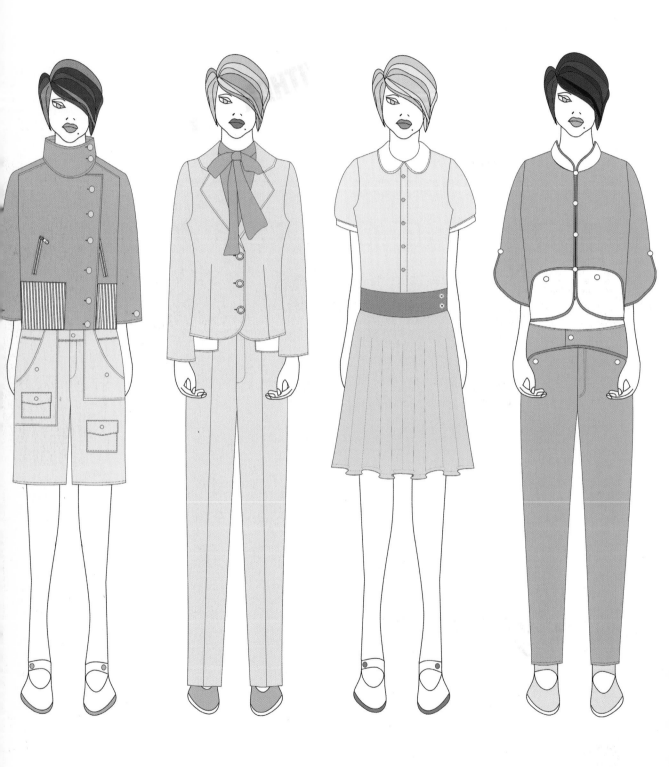

My love of fashion began when I started making clothes for my Barbie doll at four years old. I was designing by the age of eight. A natural union had taken hold and my relationship with fashion design has become one of the most significant affiliations of my life. I've found that people who work in fashion are amongst some of the most passionate people I've ever met. We love what we do, we know how lucky we are and the determination to succeed is endless.

Now that I teach fashion design at the London College of Fashion, I meet many eager faces that also have that same passion and determination. Helping them to achieve their goals gives immense satisfaction. I recommend my students equip themselves with as much knowledge as possible, and I believe this book will help both the novice and the more experienced designer to do just that. If you feel your calling may be fashion, then I hope this book will help you find out if it really is.

Linda.

ABOUT THIS BOOK

This is an invaluable resource for womenswear fashion designers, with more than 500 detailed illustrations to provide the building blocks for designing imaginative and original clothing.

DIRECTORY OF SHAPES
(Pages 38–123)

The directory forms the main part of the book and comprises a vast resource of unique and original design detail ideas. This invaluable resource will provide the most creative designer with a wealth of ideas and inspiration. Set out by garment detail for easy reference, intended use and the suitability of fabric are also included.

DETAILS IDENTIFIED

Each garment is described in detail and identified using its correct terminology.

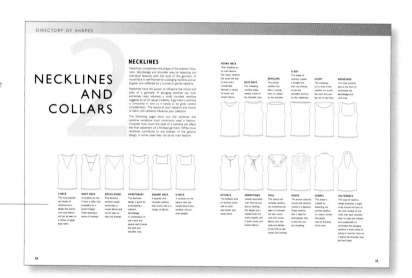

FLAT LINEWORK

The linework shows construction of garment details.

APPROPRIATE WEIGHT OF TEXTILE

Some garment styles lend themselves to certain textile weights better than others. You can refer to the textile directory in the back of the book for specific fabric recommendations.

CATWALK PHOTOGRAPHS

Photographs are used to show aspects of the artwork in the context of actual finished garments.

THE DESIGN PROCESS
(Pages 10–37)
The opening section describes the design process, from creating moodboards to working with textiles on a dress stand.

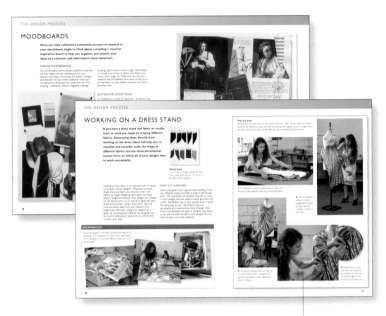

FASHION STUDENTS AT WORK!
See how students fine-tune their ideas.

THE TEXTILE DIRECTORY (Pages 124–137)
The Textile Directory is packed with advice on getting the best from different fabrics. Organized by weight and fabric, each sample is represented by a photographic swatch.

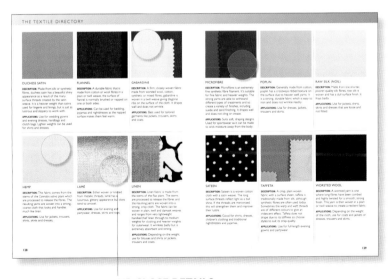

UP-CLOSE DETAILS
Some textiles are shown with enlarged details to illustrate the nature of the weave.

HOW TO USE THE FIGURE ON THE FOLD-OUT FLAP

Use the outline figure on the fold-out flap (opposite page 143) to design a prototype fashion collection.

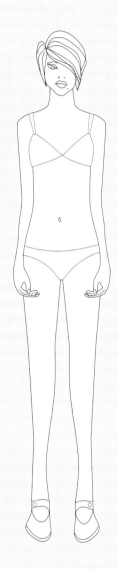

1 Place layout paper (thin, opaque paper) on top of the figure and draw freehand garments and whole outfits directly on top of the figure.

2 Copy the basic shape from any garment in the directory onto layout paper. Lay the tracings on top of the figure to get an impression of how they would look when worn. Create new designs by mixing and matching details from other garments by tracing them onto the layout paper.

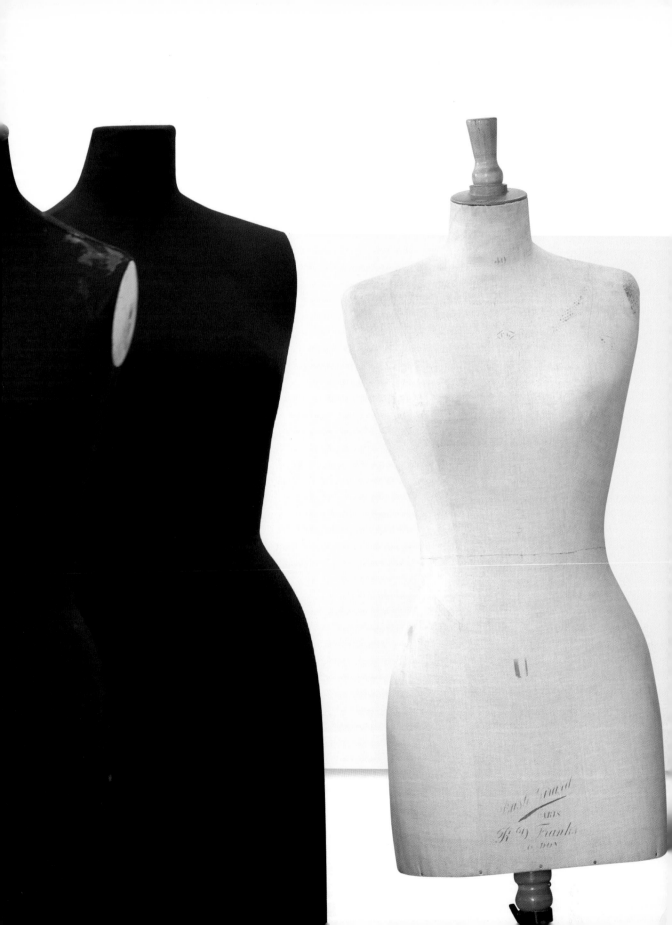

CHAPTER 1

THE DESIGN PROCESS

This chapter introduces a series of steps that will guide you through the process of designing clothes. Each step is fully explained and includes invaluable practical visuals. Completing each stage will provide you with the necessary building blocks to create original clothing designs.

THE DESIGN PROCESS: AN OVERVIEW

Creating a fashion collection from scratch is a process of development defined by seven key stages, each one of which represents a further layer of refinement.

DO YOUR RESEARCH (PAGES 14–15): Investigate ideas and concepts that you can utilize and adapt for inspiration in order to kick-start the design process.

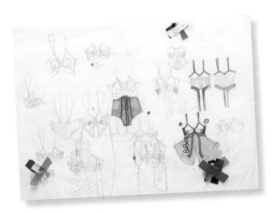

DEVELOP YOUR DESIGN (PAGES 18–19): Explore your best ideas with chosen silhouette shapes and garment details.

DEVELOP A MOODBOARD (PAGES 16–17): Select your best ideas and create a moodboard to give your collection a theme and an individual look.

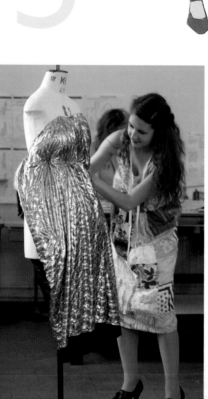

WORKING ON A DRESS STAND (PAGES 20–24): See how ideas can be explored by working with fabrics on a dress stand.

UNDERSTANDING PROPORTIONS (PAGES 24–25): A key to successful design is a sound knowledge of the female form and garment proportions, and an understanding of how subtle changes can affect your finished "look".

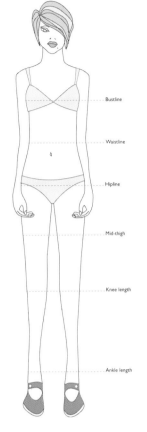

Bustline

Waistline

Hipline

Mid-thigh

Knee length

Ankle length

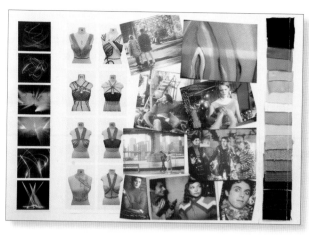

CHOOSE COLOUR (PAGES 30–33): Create your colour story and select the right fabrics for your collection.

DEFINE YOUR SILHOUETTE (PAGES 26–29): Identify factors that have affected the female silhouette in the twentieth century.

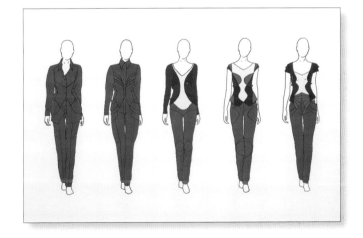

THE WHOLE PROCESS (PAGES 34–37): Follow the work of one designer from research ideas through to the finished garment.

RESEARCH

The first stage of the design process involves thorough research. This will provide a comprehensive framework for developing your capsule collection and inspire the direction of your designs. Indulge your creativity and individuality by selecting a subject or concept that fascinates, intrigues or even mystifies you.

FINDING YOUR INSPIRATION

Inspiration can come from anywhere. Look around your environment to analyze, explore and borrow ideas, colours, textures and shapes that stand out for you. Do you live in a city or in the country? Both urban and rural settings offer a wealth of inspiration. Observe how people move and interact with each other. What are they wearing and how are they wearing it? What do their clothes say about them? Come up with a theme, a story or a philosophy for your collection. Document your visual explorations with drawings and photographs.

WHAT KIND OF DESIGNER ARE YOU?

Observe international catwalk shows and consider the themes that help define the looks of different collections. Are there any giants from the world of fashion that you particularly admire? Most world-famous designers have a trademark look. British designer John Galliano is well known for his exuberant, over-the-top creations that reach back to different historical epochs. American designer Calvin Klein uses simple, tonal colour schemes to create streamlined, well-tailored clothes that are effortlessly sophisticated. Japanese designer Issey Miyake opts for sharp, futuristic outfits fashioned from the latest available offerings in fabric design and technology.

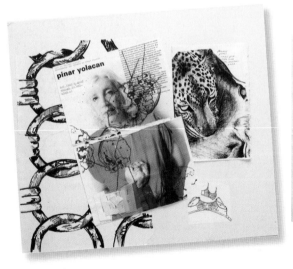

The butcher's apron

This designer gathers inspiration by researching in books, looking on the internet, drawing from objects and by visiting unusual locations, in this case a meat market.

Part of her inspiration comes from looking at the work of Pinar Yolakan: an artist who creates works using raw meat. Research informs the designer to use the colours of animal carcasses, and she finds inspiration and shape ideas from the traditional butcher's apron.

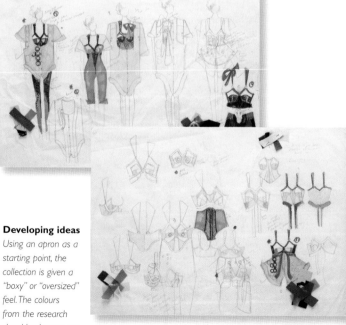

Developing ideas

Using an apron as a starting point, the collection is given a "boxy" or "oversized" feel. The colours from the research sketchbook page are carried through into the designs, and the designer considers using a print on the garments. She layers her garments and plays with the idea of fitted garment worn over loose ones. Underwear is also considered for use as outerwear.

USING YOUR SKETCHBOOK

A sketchbook can contain all of the creative solutions you need to bring your fashion collection to life. In it you can record every stage of your research and thought process.

- Collect ideas that will inspire shape, colour and texture in your collection.

- Concentrate on generating a wealth of possibilities rather than creating finished pieces.

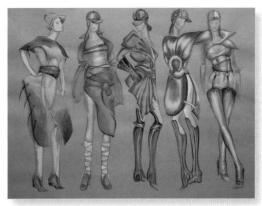

The designer deconstructs a saddle, and integrates and expands its component parts into clothing designs. Some parts of the clothes are made from leather, while others are made from woven fabrics. Visually there is a clear link from research to design ideas.

Equestrian-themed

An equestrian theme leads the designer to take a close look at leather saddles. Time is spent observing, drawing and colouring the saddle and analyzing its parts.

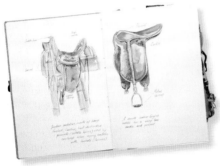

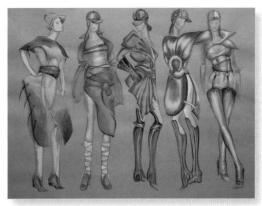

The final design is a structured boxy printed shirt that has been framed by black binding. A horse-shoe neckline reveals part of the undergarment made from brightly coloured stretch Lycra.

GETTING STARTED

Successful design is underpinned by well-defined ideas, so any aspiring designer should do research. A sketchbook is an excellent way of collecting ideas. These ideas are developed through drawing, note-taking, personal interpretation and investigation before being taken forward into initial designs for the actual garments.

Research is a multilayered and highly individual process. Visit art galleries, museums, libraries, bookshops – even flea markets and car boot sales. Look to different kinds of art and design movements for inspiration and gather as much visual data as you can. Collect postcards, take snapshots of interesting objects, jot down notes and make sketches. It is always better to have too much information rather than too little.

Study the leading designers' collections – what are their signature colours? Try to determine what influences them most. Look through fashion forecast articles to see if there are any emerging trends and always remember that the best themes are often the simplest ones.

MOODBOARDS

Once you have collected a substantial amount of research in your sketchbook, begin to think about compiling a mood or inspiration board to help you organize and present your ideas as a coherent and informative visual statement.

FINDING YOUR BEARINGS

You are aiming to communicate a specific mood that will then reflect the key references from your research and help to formulate the theme, concept and direction for your entire collection. Use your moodboard to showcase any visuals that you find inspiring – postcards, photos, magazine clippings, drawings, good-quality colour images. Remember to include your choice of fabrics and define your colour story (page 32). Make sure you link your research with the desired colourways so the point of inspiration for your palette, textures and fabrics becomes clear.

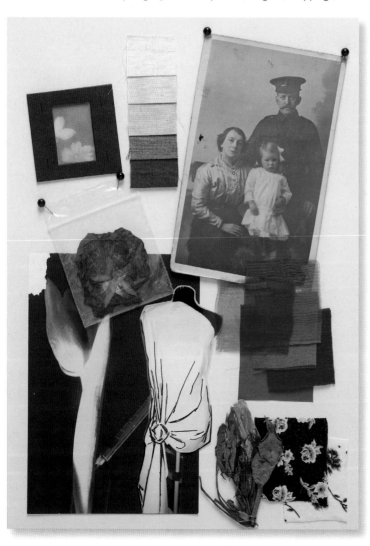

GETTING THE LAYOUT RIGHT

A moodboard is a tool of reference – its layout must be exciting if it is to function as a catalyst inspiring further design work. Here are examples of real-life moodboards drawn up by fashion students. No two boards are alike and each one will have its own distinct message and direction.

An inspiring and visually arresting layout is vital to your moodboard's success. If it is interesting, it will encourage a deeper investigation into mood and concept but also pave the way for a much more interesting capsule collection.

The size of your moodboard should be determined by how much information you have and what kind of layout you want. Move elements around on the layout before you stick anything down. Less is more when it comes to the message of your moodboard. Go for key images and don't repeat yourself by unnecessary additions. Use strong craft glue that will hold objects, as well as fabrics, card and photographs.

Once you have finished preparing your moodboard, show it to someone who is unaware of your theme or concept. Ask them to interpret its visual message. If they understand it without further prompting, you have created a successful moodboard. If not, then perhaps rethink its content and consider how you can communicate your message more directly.

Innocence of childhood

The moodboard's theme is the "innocence of childhood". The message is translated into a collection of images that include a vintage postcard, flowers, bows and fabric colourways. The idea of a bow, taken from the postcard, is explored on the dress stand using calico fabric.

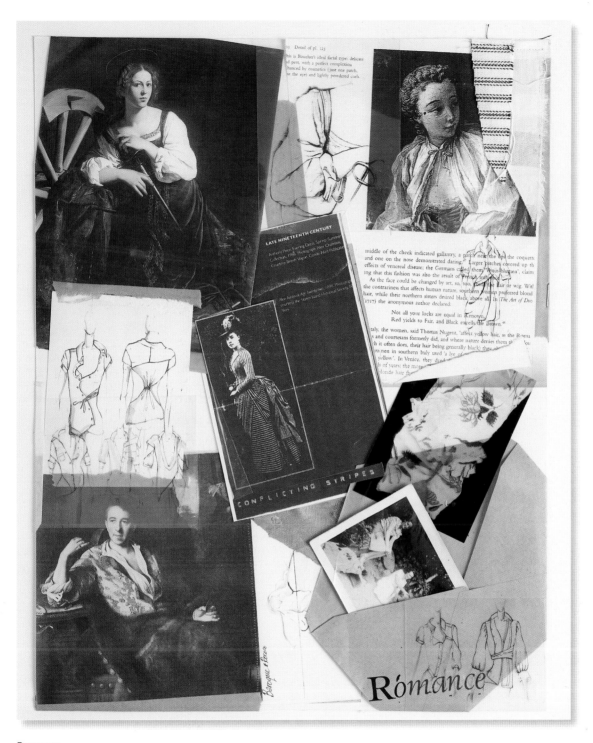

Romance

Another theme is "romance". The designer has been inspired by period outfits from the eighteenth century, looking specifically at volume and draping from the clothing details. Fabrics inspired by the period have been collected and ideas are beginning to emerge. The designer looks closely at fabric volume, draping and twisting.

DESIGN DEVELOPMENT

The stage at which you begin to lift ideas from the moodboard and start to transfer them onto a drawing model is called design development. There are no hard-and-fast rules about how you go about this. The skill lies in developing concepts by pushing them in interesting directions. Think of your capsule collection; you should aim to prepare a variety of styles that vary in length, cut, fabric and colour. Remember that while not all designs may work, the process is part and parcel of creating a successful fashion collection.

REFINING YOUR COLLECTION

Make sure you choose and work through one or two ideas at a time. You may, for instance, want to team up a pair of well-tailored trousers and a jacket with a dramatic décolleté, or combine a simple shirt and a pencil skirt with an eye-popping detail on the hem. Aim for items that are wearable and carry an echo of the original theme. Follow the progression of an idea from its origins in the research sketchbook through to its inclusion on the moodboard and its further evolution at the development stage. These transitions are the building blocks of the design process.

To create a successful collection, all the upper-body garments (jackets, coats, sweaters, cardigans, shirts, tops and T-shirts) should be able to be worn in combination with all lower-body items (trousers, skirts and shorts). Also important is the balance of detail on your individual garments. Is the width of the collar balanced with the pocket? Does the cuff look like it belongs on another shirt? Decide the details you will focus on and carry them throughout the capsule collection. Over-designing clothing is easy; the skill is in your use of restraint.

Using a children's bow as the genesis for a design

Taking a traditional childrenswear detail as her starting point, this designer uses a ribbon bow to influence her designs. You can see how the bow idea changes and develops, starting as a sleeve detail, being used on a shirt hem, and finishing on the neckline of a shirt.

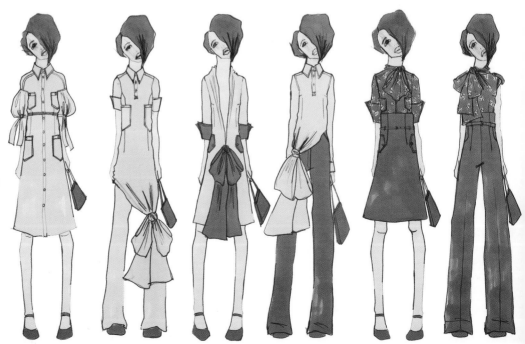

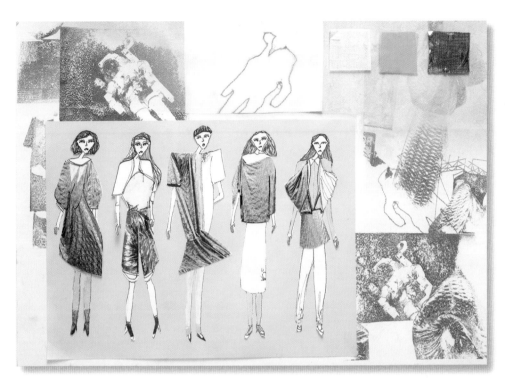

Choosing fabrics

These designs have been inspired by space travel and space suits. The main fabrics are a blue-grey tweed and a futuristic silver stretch jersey. The designer has draped the fabric on a dress stand and uses the ideas to begin to formulate a range of clothing shapes.

Choosing details

This designer is developing an equestrian-themed collection. The silhouette is fitted and reflects the leanness of a horse. Stirrups taken from the saddle have been used as the key details on the outfits.

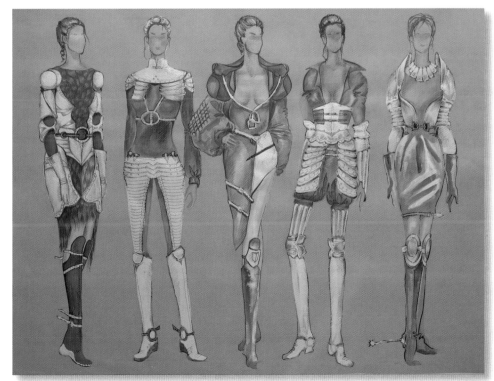

WORKING ON A DRESS STAND

If you have a dress stand and fabric or muslin, start to work out shape by draping different fabrics. Generating ideas directly from working on the dress stand will help you to visualize and consider scale, the drape of different fabrics and the three-dimensional human form, on which all of your designs have to work successfully.

Textile board
It is not until the designer drapes the fabric from a dress stand that the true identity of the fabric will be revealed.

Getting to know fabric is an important part of being a successful fashion designer. Whenever possible, drape the actual fabric you intend to work with before you begin designing: learn about its drape, stretch, weight and texture. Your designs are created for the female form, so it's natural to generate ideas three-dimensionally, using a dress stand. Take the most successful ideas from your research and experiment with them, using your research as a guide. By recording your ideas as you progress, you will build a reference of ideas that you will be able to draw upon later.

HOW IS IT HANGING?

Fashion designers have a good understanding of the way different shapes and fabrics hang on the female form. This awareness will develop naturally as more of your designs become ready-to-wear garments and outfits. Remember that no two people work in quite the same way, so don't be afraid to let your personality and creative drive shine through. Take time to contemplate the type of designer you aspire to be, and consider the fabrics and designs that you want to see in your final collection.

PREPARATION

Resourceful designers never throw anything away! Keep all your sketchbooks and moodboards and refer to them often. Always have a sewing box on hand, with different threads, pins and sizes of needle.

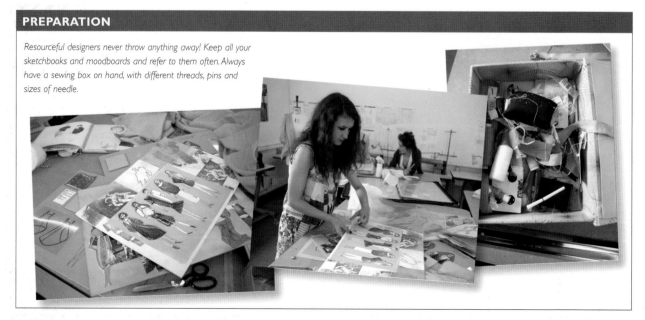

Trial and error

Working from the dress stand is a trial and error process – often the best results are achieved accidently. Be prepared to record your work by drawing or photographing from all angles around the dress stand, as your back and side views are just as important as the front view.

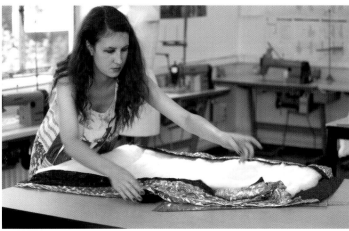

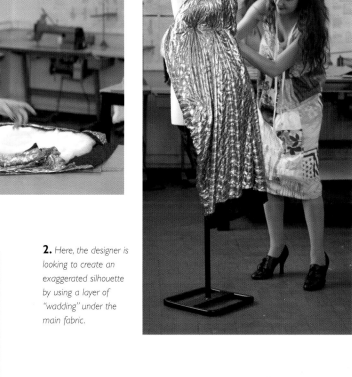

1. *It's important to work on surfaces that are clean and free from clutter especially when you are handling fabrics.*

2. *Here, the designer is looking to create an exaggerated silhouette by using a layer of "wadding" under the main fabric.*

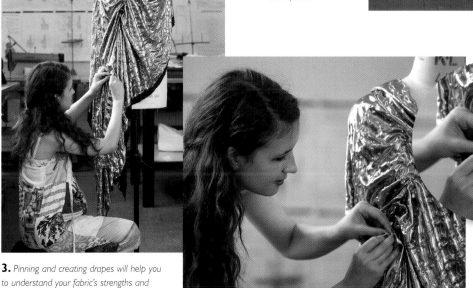

3. *Pinning and creating drapes will help you to understand your fabric's strengths and possible weaknesses, as well as generate ideas for designs.*

4. *Intricate work requires care, time and thought. As you develop your ideas you will naturally begin to edit and focus on the best ones.*

Finalizing your garment

Sometimes the creation of clothing requires that you take a step back and finish an important detail by hand to achieve the look you are after.

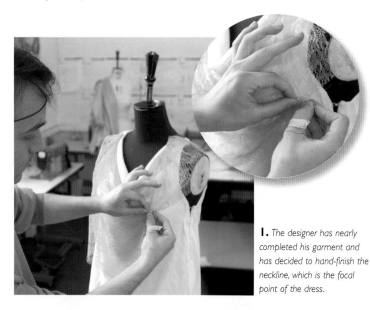

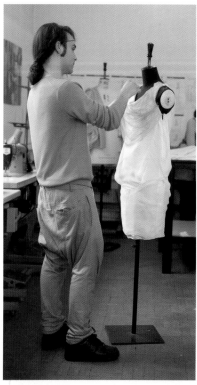

1. *The designer has nearly completed his garment and has decided to hand-finish the neckline, which is the focal point of the dress.*

2. *The designer considers the visual impact of the yellow lace against the white chiffon background. He continues to adjust until he is happy.*

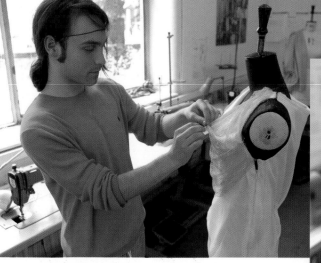

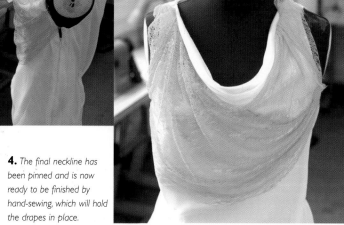

3. *Here, the designer is altering the regularity of the drapes and pintucks on the neckline.*

4. *The final neckline has been pinned and is now ready to be finished by hand-sewing, which will hold the drapes in place.*

CHOOSING A DRESS STAND

Dress stands are vital to the work of fashion designers. Increased familiarity with the female torso will improve your understanding of successful clothing designs and the way fabrics work against the body.

Dress stands vary in sizes. Designers usually work on size 10 or size 12 to produce clothing samples for their collections. Dress stands are traditionally covered in calico with a thin layer of wadding that allows for dressmaker pins to be inserted when you need to hold fabric in place.

Specialized dress stands include the outerwear form that has been graded bigger than the average with capped sleeves. A collapsible shoulder dress stand is good for close-fitted garments and the lower body dress stand is excellent for fitting and draping skirt or trouser shapes.

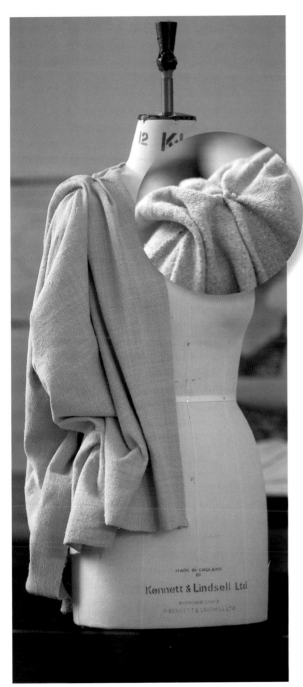

Focus on details
By recording interesting details you may begin to think about where else they might be used on a garment and what else they could turn into. Perhaps you will have an idea for a collar, a hem detail or a pocket?

DRESS STAND SHAPES

Which dress form?
Choosing the correct dress stand for your requirements is crucial. A well-purchased dress stand is fundamental to your work as a designer and will last for decades.

1. *Collapsible shoulder dress stand.*

2. *Lower body dress stand.*

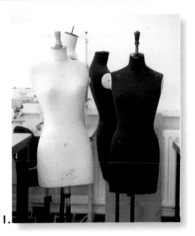

1.

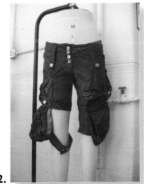
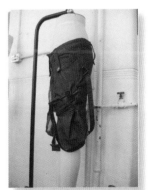

2.

UNDERSTANDING PROPORTIONS

Clothing that fits well and flatters the natural shape of the body has the power to enhance and enrich people's lives and how they feel about themselves. For centuries the female form has been studied, painted and admired for its natural curves, particularly around the bust, waist and hip areas. Understanding the female form and garment proportions is key to the finished "look" of your design.

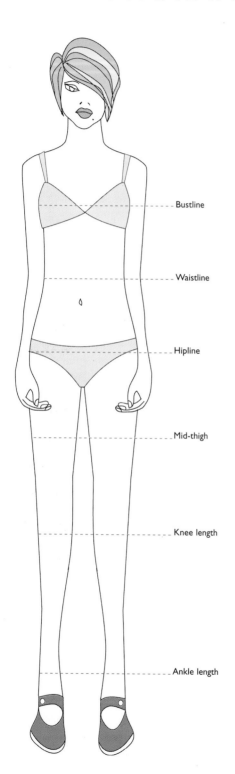

Bustline

Waistline

Hipline

Mid-thigh

Knee length

Ankle length

CONSIDERING YOUR DESIGNS

As well as being practical, designs should flatter the women who wear them. Not all women are confident about their body, and most have something they would like to change. As no two women have the same body shape you should offer variety in the proportions of your capsule collection and let the wearer decide what suits them the best.

Always consider the proportions and lengths of garments you are designing and how they will work together in your final collection. The guide on the opposite page will help you to think about garment proportions as you start to develop your silhouette and your designs. Practical considerations for shapely areas include fit lines or darts – unless you're working with fabric that has stretch.

Allow for individuals to wear your capsule collection in their own unique way. Perhaps a skirt could be worn over trousers, a cardigan worn over a dress or shorts, or possibly a knee-length jacket worn over Capri trousers.

Think about how layers of clothing will work with each other on outfits, and consider the variety of proportions that need to be presented in your capsule collection. Vary the lengths of your skirts, trousers, jackets, coats and dresses to create a comprehensive collection.

Reference points

The female form has been divided into reference points. As you are designing be aware of these reference points in relation to your garments. These points will become vital once you have completed designing your capsule collection and begin working on creating paper patterns for your garments.

Garment proportions

Your capsule collection should contain a good variety of garments in varied proportions, and in addition you should learn the names of these lengths. These figure templates indicate the proportions and lengths of different fashion separates and can help you with your measurements.

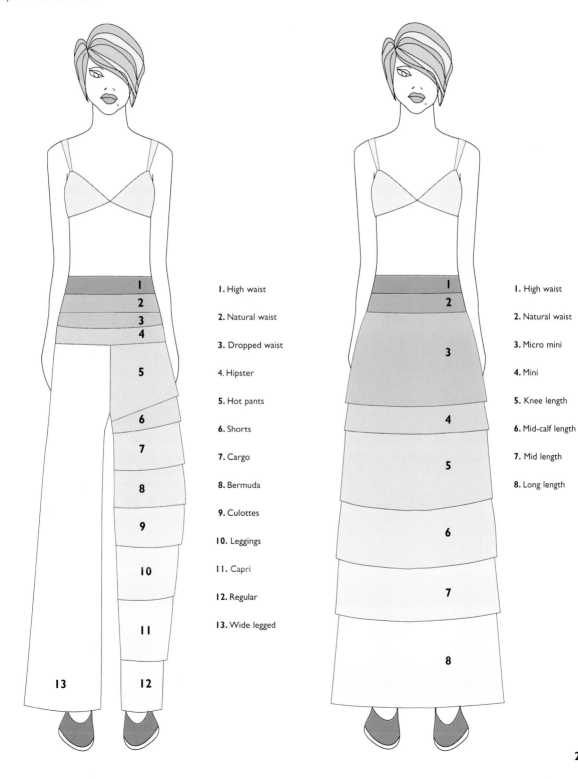

1. High waist

2. Natural waist

3. Dropped waist

4. Hipster

5. Hot pants

6. Shorts

7. Cargo

8. Bermuda

9. Culottes

10. Leggings

11. Capri

12. Regular

13. Wide legged

1. High waist

2. Natural waist

3. Micro mini

4. Mini

5. Knee length

6. Mid-calf length

7. Mid length

8. Long length

DEFINING SILHOUETTE

Silhouette shapes are defined by the way in which garments hang or drape on the human body. In today's competitive fashion world, companies invest a lot of time, money and creative effort in developing signature silhouettes to make their ranges stand out and give their brand immediate visibility.

Begin by identifying what you believe currently defines silhouette. Observe what people are wearing, examine proportions presently regarded as fashionable and the outline created by garments when worn. Work within this visual framework to develop your own variations based on influences that stem from your research, the contents of the moodboard and your choice of fabrics.

Generally a silhouette develops slowly from decade to decade and there are many external factors that affect the change. It is only with knowledge of what has happened in the past that we can begin to

create something new. Often designers will reference the past in their work, and all designers should be familiar with the history of the female silhouette. Having a historical perspective will help to inform your current design work, give your designs a greater depth of creativity, and will also provide you with a useful talking point when you are describing your garments.

Here is an overview of the women's silhouette throughout the twentieth century. As part of your own creative-thinking process, you should expand your knowledge of historical and vintage clothing.

A CENTURY OF SILHOUETTE (1900–2000)

In the course of the last century, silhouette has undergone a continuous process of reinvention. Let us take a closer look at the influences and factors that helped define the concept of silhouette in every decade.

1900 SILHOUETTE

The time The Victorian era from 1900 to 1914 was dubbed the "Age of Opulence" and its fashion rules were strict and rigid. Not adhering to them could lead to social exclusion since attire indicated vital statistics such as age, status and social class.

Silhouette Hemmed in by a corset, the female silhouette was an S-shaped or hourglass figure with a tiny waist and a mono-bosom balanced out by a rounded derrière. If the posterior was ill-defined, a small bustle was worn underneath the skirt for extra lift.

Accessories Tiny feet were also in vogue, with women purposefully wearing shoes several sizes too small and, in some extreme cases of fashion fanaticism, bones were even excised from toes to make feet look daintier.

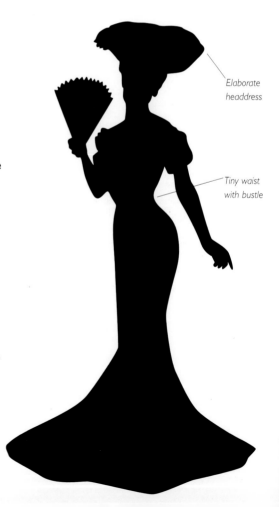

Elaborate headdress

Tiny waist with bustle

1910 SILHOUETTE

Oversized hat

The time 1914 was the breakout of World War 1 and this decade was a period of tremendous change. The invention of motorized vehicles, the suffragette movement, a female labour force and an increasing sense of financial and social independence meant that the restrictions of the corset were no longer suitable for this new way of life. The war also encouraged people to be less frivolous.

Trailblazers French designer Paul Poirot led the way by designing a less restrictive silhouette.

Silhouette Influenced by the shapes and colours of Middle Eastern dress and harem skirts, Poirot's designs gave birth to the hobble skirt. Although easier to wear than the corset, its hems were so narrow that walking was difficult. As the decade progressed, hems were raised an inch or two and skirts shifted away from the hobble to more wearable bell-shaped designs, some of which had pleating or tiers teamed up with a soft, round-shouldered look.

Accessories The silhouette was completed by a large cartwheel-sized hat.

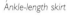

Ankle-length skirt

1930 SILHOUETTE

Narrow shoulders

The time In the thirties, worldwide recession and mass unemployment sparked by the Wall Street crash turned into the Great Depression. Parisian fashion houses suffered a significant loss of business. Many tried to slash their price tags and introduced cheaper diffusion lines.

Slim waist

Silhouette The sleek, shapeless style of the twenties was replaced by a softer, more feminine silhouette which accentuated curves and returned the waistline to its natural position. For the first time, the length of skirts depended on the time of day and capes were worn over capped sleeved dresses. Women led busier lives and this versatile yet functional sense of fashion reflected the new way of life. Physical fitness was also celebrated with ever-shorter skating skirts and shorts worn in public.

Graceful flare

1920 SILHOUETTE

The time In the roaring twenties a new silhouette known as "la garçonne" emerged.

Trailblazers Leading exponents of the look were French designers Coco Chanel and Jean Patou.

Silhouette The style was one of slim hips, flattened chests, broader shoulders and dropped waists. The length of skirts skimmed the calf for most of the decade with variations of handkerchief and asymmetric hems allowing for the appearance of a shorter style. This simpler silhouette enabled home dressmakers to copy designs and the latest fashions became more accessible to all, not just the wealthy.

Accessories A short, boyish or Eton crop, and cloche hat.

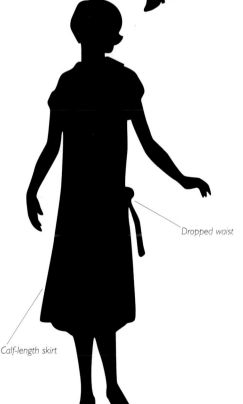

Dropped waist

Calf-length skirt

1940 SILHOUETTE

The time With the onset of World War II, the textile industry in Europe was forced to dedicate its production lines to the war effort. Isolated from the outside world, Paris lost its title as the capital of fashion and some homegrown designers fled to New York and London. During the war years, frivolity was seen as unpatriotic and clothing became more functional than ever before. Women began serving in the armed forces and the rest kept "the home fires burning".

"Make do and mend" was the wartime motto; the lack of new textiles forced women to become resourceful and creative. Pillowcases were turned into shorts, dresses were made from curtains, and blankets were re-used to make coats. Nothing went to waste.

Trailblazers The war finally ended in 1945, and two years later, French designer Christian Dior launched his New Look. It was dismissed by both British and American governments as wasteful and people were discouraged from wearing such extravagant designs. The stage, however, was set for the arrival of a revolutionary silhouette.

Silhouette The forties silhouette was quite military in look with padded square shoulders and practical knee-length skirts.

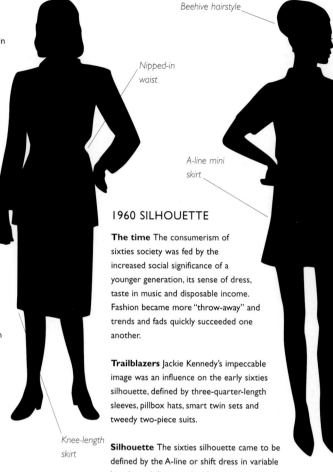

Beehive hairstyle

Nipped-in waist

A-line mini skirt

Knee-length skirt

High collar

Shapely jacket

Fitted skirt

1960 SILHOUETTE

The time The consumerism of sixties society was fed by the increased social significance of a younger generation, its sense of dress, taste in music and disposable income. Fashion became more "throw-away" and trends and fads quickly succeeded one another.

Trailblazers Jackie Kennedy's impeccable image was an influence on the early sixties silhouette, defined by three-quarter-length sleeves, pillbox hats, smart twin sets and tweedy two-piece suits.

Silhouette The sixties silhouette came to be defined by the A-line or shift dress in variable lengths and the mini-skirt became the decade's flagship garment. Androgynous boyish looks were all the rage as epitomized by Twiggy. Hair was worn very short or piled up into a beehive.

1950 SILHOUETTE

The time In the fifties, Paris regained its crown as fashion capital of the world.

Silhouette In the post-war years, women were encouraged to be the ideal wife or homemaker and wore trim bodices and full knee-length skirts or short, fitted boxy jackets and blouses with pencil skirts. New and varied silhouettes emerged because women had been starved of glamour for so long. Hallmarks of the shapely fifties silhouette were soft, wide shoulders with a corseted waist and full hips. Ready-to-wear fashion became hugely important with the retail industries keen on improving quality in their eagerness to copy the latest Parisian styles. This decade marked the beginning of youth culture and consumer society as important social phenomena.

1970 SILHOUETTE

The time The seventies heralded the women's liberation movement and equal rights (including pay). Increased opportunities for travel meant that influences from around the globe came to impinge on fashion. Kaftans, kimonos and the djellaba (a Moroccan robe with a pointed hood), plus styles from the Indian subcontinent and Africa, were translated into robes and other comfortable garments. World crafts like macramé and crochet became fashionable.

Silhouette The more relaxed, longer seventies silhouette was one of floating romantic fabrics and peasant overtops that swung and flared away from the body hiding the waist or flared and bell-bottom trousers worn with platform shoes. Hairstyles included straightened locks with flicks. Subcultures like punk rock and disco also contributed to dictating seventies fashion.

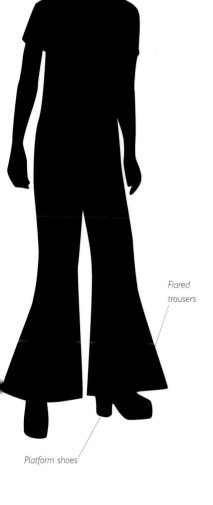

Flared trousers

Platform shoes

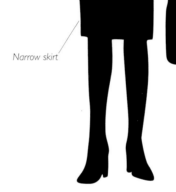

Wide shoulders

Narrow skirt

1980 SILHOUETTE

The time Designer labels and expensive cars were the way to flaunt new wealth and success in this decade of prosperity, excess and runaway consumerism. A well-performing stock market meant that some people became millionaires overnight. By now part of the workplace, women were power-dressing and competing with men on their own terms. They wanted it all – a successful career, equality and a happy family.

Aerobics and fitness classes were a new form of body worship, with leg warmers and branded sportswear proving extremely popular.

Silhouette The female silhouette was predominantly defined by huge military-style shoulder pads, oversized and colourful jewellery, wide belts, narrow skirts above the knee and pointy footwear with stiletto or kitten heels.

Narrow shoulders

1990 SILHOUETTE

The time With the nineties, less became more. A form of pared-down minimalism followed the excesses of the eighties. With the dawning of the internet, fashion became global, less dictatorial and more eclectic, effectively letting individuals pick what they liked and wanted to wear. It became easier for catwalk creations to be copied and sold in the high street for a fraction of the price of the originals. Customers were more savvy and demanding, and choice was everything.

People looked to the past for inspiration and an interest in vintage clothing and accessories continues today.

Silhouette Although the nineties had no dominant silhouette, one of the more popular looks was the stylish and sexy two-piece trouser suit. The narrowed shoulders and trousers were offset with a simple shirt and a few key accessories.

29

CHOOSING COLOURS

Fashion collections are generally designed for autumn/winter and spring/ summer. Autumn/winter collections tend to be darker and deeper, although this is not necessarily set in stone. The fabrics and colours you choose will depend largely on the season your collection is aimed at and personal choice. Look at the textiles directory (pages 124–137) to make an informed decision when selecting the fabrics for your designs.

THE POWER OF COLOUR

A vital part of the creative process, colours are chosen for their power to evoke strong emotional responses. We can tell that colours are deeply rooted in our psychology, because we use them figuratively in language to describe feelings: "I'm feeling blue", "She was green with envy".

The meaning of colour differs across cultures. In Western culture black has negative associations with death and depression, but across much of India and Africa the colour of mourning is white. In Western fashion, black is a popular and stylish colour choice – the term "new black" is often applied to whichever colour is favoured that season.

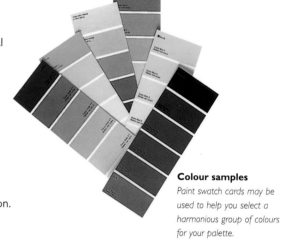

Colour samples
Paint swatch cards may be used to help you select a harmonious group of colours for your palette.

Colour combinations
A colour wheel is an excellent tool for learning about colour combinations. "Complementary colours" such as red and green lie opposite each other on the colour wheel, whereas "analogous" colours, like green and blue, lie adjacent to each other. Reds, oranges and yellows stimulate the senses and tend to be perceived as "warm" – capable of exciting feelings of stimulation, cheeriness, good health and aggression. Opposite on the colour wheel, blues and greens are seen as "cool" and have connotations of calmness, peace, safety and depression.

RED

red-violet

red-orange

violet

orange

blue-violet

yellow-orange

BLUE

YELLOW

blue-green

yellow-green

green

Visualizing the designs
Comparing fabric swatches will help you to clearly see the best colour combinations.

THE MEANING OF COLOUR

Colour is capable of evoking a strong emotional response. Colours have symbolic meanings that subtly differ depending on culture and experience, but despite local differences, certain colours do seem to have universal characteristics.

Red

Associated with fire, red has an intense, vibrant, advancing and aggressive character. Its positive associations include love, sexiness, festivity and luck, while its negative connotations include the devil, debt, revolution and danger.

Yellow

Associated with the sun, and therefore light. Though yellow is also linked with illness (jaundice) and cowardice, it is essentially the hue of happiness: sun, gold and hope.

Green

Associated with spring, youth and the environment, it helps people to feel calm. Greenish-blue is said to be the coldest of all colours. As the colour of envy, nausea, poison and decay, green has bad connotations too.

Blue

Associated with the sky, water and brightness. Its clear, cool, transparent qualities link it to detachment, peace and distance. Its downside, so to speak, is its status as the colour of depression, cold and introversion.

SEASONAL COLOURS

The fashion cycle works to the seasons of spring/summer and autumn/winter. Colours are often grouped together in a season related group – these groups of colours represent the most popular colour trends for that season. Popular choices for the autumn/winter season include black, grey, deep blues, greens and reds, muted shades of the rainbow, gold, purples, forest green and neutrals. Strong colours for the spring/summer season may include pastels, bright yellows, reds, greens, blues, controlled highlights of neon, silver, pinks and white.

Contrasting colours
The contrasting bold colours of this dress work well. The yellow is bright and cheerful, and the overall look is daring and pleasing to the eye.

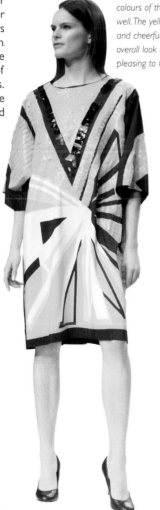

Vibrant
Red is seen in both spring/ summer and autumn/winter collections. The colour choice of extroverts, it is bold, eye-catching and has strong sensual connotations with passion and sexuality.

Neutrals
Neutrals do not draw immediate attention. Here, the subtle colour offsets the elaborately frilled blouse.

FINDING YOUR COLOUR STORY

The term "colour story" refers to the range of shades, tones and hues resulting from your research. Refer to fashion magazines and reflect on how designers use colour – why are some combinations more successful than others?

Identify the "mood" of your collection and let these findings guide your colour selection. Edit the information and ideas contained in your sketchbook to draw out an emerging colour story for your collection.

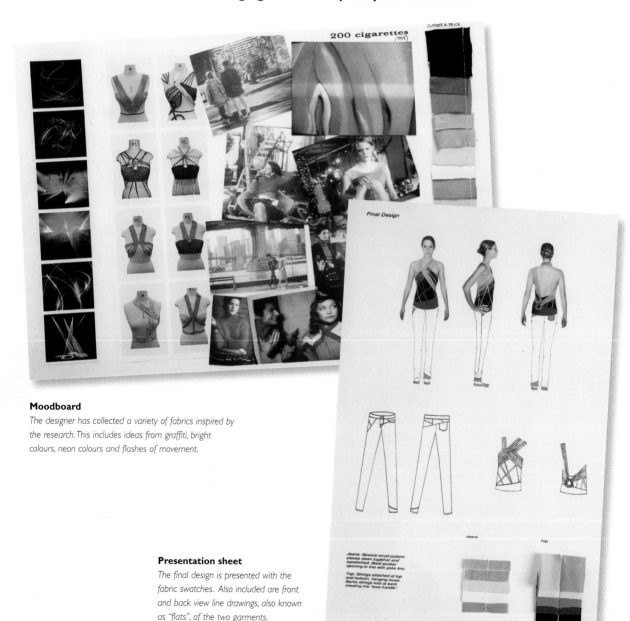

Moodboard
The designer has collected a variety of fabrics inspired by the research. This includes ideas from graffiti, bright colours, neon colours and flashes of movement.

Presentation sheet
The final design is presented with the fabric swatches. Also included are front and back view line drawings, also known as "flats", of the two garments.

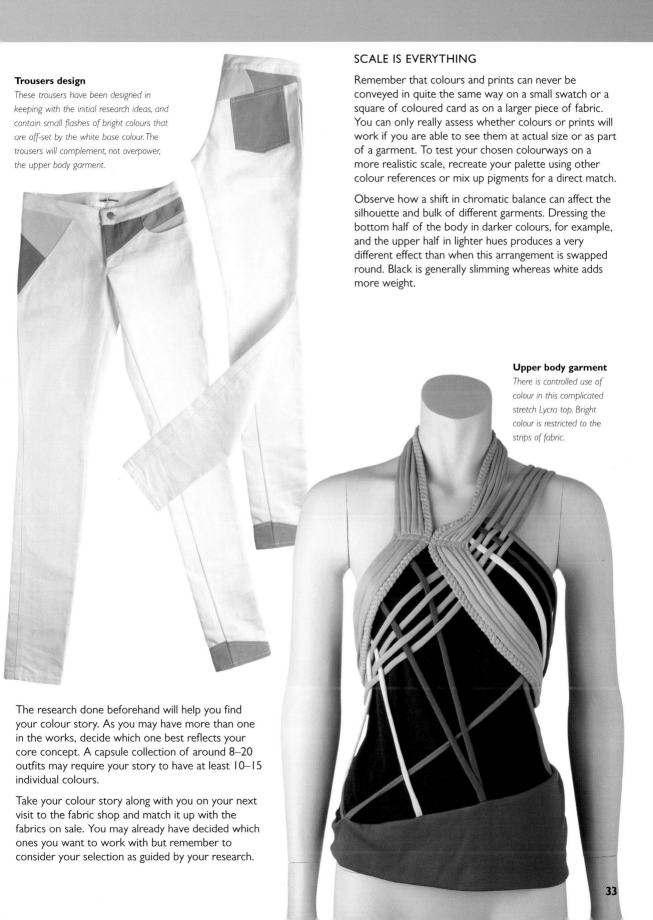

Trousers design

These trousers have been designed in keeping with the initial research ideas, and contain small flashes of bright colours that are off-set by the white base colour. The trousers will complement, not overpower, the upper body garment.

SCALE IS EVERYTHING

Remember that colours and prints can never be conveyed in quite the same way on a small swatch or a square of coloured card as on a larger piece of fabric. You can only really assess whether colours or prints will work if you are able to see them at actual size or as part of a garment. To test your chosen colourways on a more realistic scale, recreate your palette using other colour references or mix up pigments for a direct match.

Observe how a shift in chromatic balance can affect the silhouette and bulk of different garments. Dressing the bottom half of the body in darker colours, for example, and the upper half in lighter hues produces a very different effect than when this arrangement is swapped round. Black is generally slimming whereas white adds more weight.

Upper body garment

There is controlled use of colour in this complicated stretch Lycra top. Bright colour is restricted to the strips of fabric.

The research done beforehand will help you find your colour story. As you may have more than one in the works, decide which one best reflects your core concept. A capsule collection of around 8–20 outfits may require your story to have at least 10–15 individual colours.

Take your colour story along with you on your next visit to the fabric shop and match it up with the fabrics on sale. You may already have decided which ones you want to work with but remember to consider your selection as guided by your research.

THE WHOLE PROCESS

The design process has been broken down into stages, from finding inspiration and doing research, creating a moodboard, developing your designs and working on the dress stand, to understanding proportions, silhouettes and colour. This process guides your thoughts and actions, but remember, no two designers work in the same way. Once you have gained confidence you will find working methods that suit you.

Key image

The inspiration for the capsule collection is based on a motorcycle rider's outfit or "biker's leathers".

Biker's leathers are designed to protect motorcycle riders in accidents and to prevent injury. The designer has found a key image of a stunt motorcycle rider. She analyzes the image and is inspired by the structure, fit, protection and curved lines of the outfit.

FROM BEGINNING TO END

Here we follow the work of one fashion designer as she travels through the design process, watching from the beginning of her research and design development, through to the final finished garment.

As demonstrated by this designer, your clothing range will need to be transferable across the board, so that all garments look good and work well together when showcased side by side in a line-up. Fabric selection is vitally important because your choice of fabrics and colourways will need to function as a visually harmonious whole.

Textile board

The research idea inspires the designer to collect a range of stretch and woven fabrics. The designer begins to consider the collection's colourways and teams fabrics together for their suitability. The layout of the board allows her to visualize the fabrics as clothing designs.

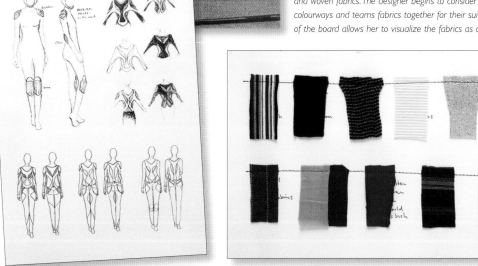

Initial ideas

The designer is dissecting the inspiration and is using this space to begin to explore initial ideas.

DESIGN DEVELOPMENT

In the design development stage, the designer takes inspiration from the curves and lines of the biker outfit and begins to apply these ideas to a range of womenswear clothing. The silhouette is lean and fitted and has been directly inspired from the research source. The ideas are worked through one by one, changing and developing gradually. The designer develops her ideas through the spectrum of the women's wardrobe, from jackets to dresses, trousers and skirts.

1. The designer works on a fitted silhouette inspired by her research. She creates a curved bodice with capped sleeves. The trousers have side protection panels, inspired by the biker theme.

2. The bodice and the cut of the trousers are modified. The side protection panels are removed, but the same length of trousers is still considered. The front panel detailing on the top is also changed.

3. Long sleeves are added to the top. The stretch cream fabric is used in a prominent way, which places greater emphasis on the front panel of the top. The trousers are simplified and include a kneepad detail.

4. The balance and combination of colour on the top is modified. The neckline is lowered and offset by the grey coloured stretch fabric. The bodice remains fitted with lots of detailing. The trousers have side pocket and kneecap detailing.

5. The designer considers a balanced capsule collection and introduces a dress. The dress is similar to the top with lots of curved fitted style lines and a new frill detail. The silhouette remains fitted and narrow.

6. A woven fabric is used to create a two-piece outfit inspired by the curves and lines of the biker's leathers. The shirt has a sharp collar with button stand and side seam, and front bodice stitch detailing.

7. The focus of this two-piece outfit made in a woven fabric is the concentration of curved style lines around the bust and hip.

8. The jersey stretch is reintroduced for the upper body garment. The outfit has been pared down and the designer considers the graphic effects of minimum style lines.

9. Woven mixed with stretch, this outfit sees the designer pushing her ideas further. The semi-circular lines of the top are reflected and balanced with similar lines used on the trousers.

10. With a change of neckline shape and focus of style lines, the outfit has balance and is in keeping with the theme and mood of the rest of the capsule collection.

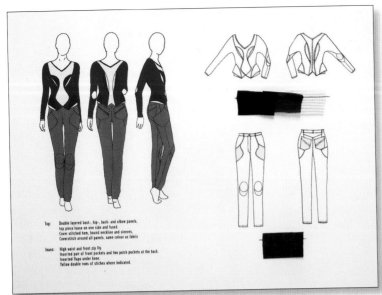

Top: Double layered bust-, hip-, back- and elbow panels,
top piece loose on one side and fused.
Cover stitched hem, bound neckline and sleeves.
Coverstitch around all panels, same colour as fabric

Jeans: High waist and front zip fly.
Inserted pair of front pockets and two patch pockets at the back.
Inserted flaps under knee.
Yellow double rows of stiches where indicated.

Final presentation sheet
The final presentation sheet contains all of the information about the outfit. This includes swatches of fabrics, front, back and side views, and flats or spec drawings of each of the garments.

Design is about individual interpretation and vision, there are no set rules for how you go about the design process. Try to follow the guidelines suggested at each stage and remember to give yourself the necessary freedom to explore and break the rules once you have gained more experience and confidence.

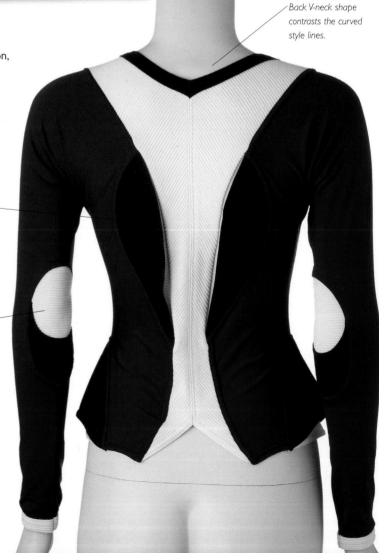

Back V-neck shape contrasts the curved style lines.

Inserted vents allow room for the arms to manoeuvre.

Elbow inserts protect and give extra comfort to the narrow sleeve.

Back view
The designer has considered the garment as a whole, and the design of the back echoes the front.

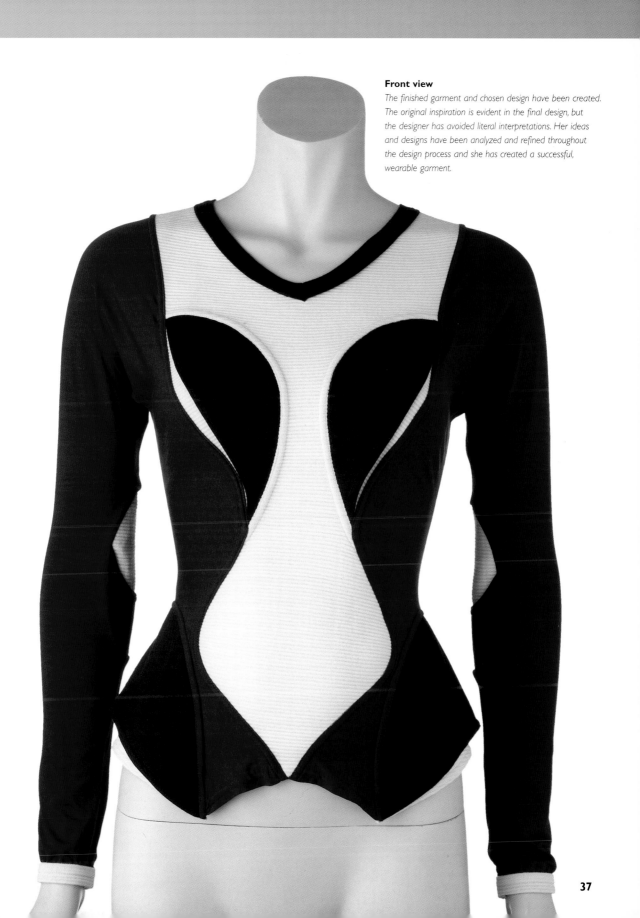

Front view

The finished garment and chosen design have been created. The original inspiration is evident in the final design, but the designer has avoided literal interpretations. Her ideas and designs have been analyzed and refined throughout the design process and she has created a successful, wearable garment.

CHAPTER 2

DIRECTORY
OF SHAPES

The directory of shapes is a vast
resource of garment shapes and
details. This chapter will familiarize
you with the names of the many
different details and shapes used in
fashion design, as well as provide a
visual context for how these work on
actual garments.

SLEEVES

An essential part of designing clothes is knowing the correct names for the different elements of a garment. On these two pages you will discover the commonly used terms for classic sleeve designs, with clear illustrations of what each type looks like. These will help you research sleeve shapes to decide what style of sleeve a design should have.

Sleeves are an essential part of the design of garments for the upper body, and in some cases will be the defining aspect of a design. Once in tune with the rest of the garment, sleeves will complement a finished design, so choosing the correct style of sleeve is essential – over the next few pages you will discover just how many variables are involved. Sleeves have a function – to provide the wearer with a cover for the arms – which means a well-designed sleeve will marry function, wearability, comfort and style.

SLEEVELESS

Sleeveless sleeves are generally worn in the summer and are often seen on T-shirts.

FRILL

The frill sleeve has a playful and summery feel. It works well with drape fabrics such as chiffon or crêpe.

SET-IN SLEEVE

Set-in sleeves are the most popular style of sleeves in garment design. Transferable across all types of fabrics and styles, this versatile sleeve can be used in endless ways.

RAGLAN

Raglan sleeves are sometimes seen on sportswear and knitwear. A raglan sleeve will give the shoulder line a gentle, rounded look. This style of sleeve can also be used with woven fabrics.

SADDLE

A variation of the raglan, a saddle sleeve keeps the rounded shoulder look and provides the comfort and fit of a raglan. The sleeve head gives the shoulder a square look. A saddle sleeve can be used in fully-fashioned knitwear garments.

DROPPED SHOULDER

The dropped shoulder can often be seen in casual garments such as sweatshirts. The style is also transferable to woven fabrics and is often used for coats and jackets.

CUT-AWAY SHOULDER

Emphasizing one of the most alluring parts of the female form, the cut-away shoulder focuses and frames the shoulders. Choose a fabric with good stability for the best results and finish.

BISHOP

The bishop sleeve has a normal set-in sleeve armhole with gradual width added throughout the length. The fullness of the bishop sleeve is gathered into a cuff.

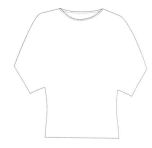

DOLMAN

The dolman sleeve originates from the Magyars in Hungary and was worn by the peasants there. Similar to the batwing, a dolman has a large armhole and is cut to extend from the bodice with a narrow cuff.

FLUTED

The fluted sleeve creates a romantic look. A wide sleeve is gathered by either elastic or drawstring on the upper arm, which allows the lower part of the sleeve to drape along the rest of the arm.

BELL

Introduced in the second half of the nineteenth century, the bell sleeve has a normal set-in sleeve armhole, which then flares towards the lower edge of the sleeve creating a bell shape.

SLIT

Versions of the slit sleeve were popular during the 1970s. A simple sleeve with a slit detail provides flare at the cuff.

BATWING

The batwing sleeve was popular during the 1930s and 1980s. The batwing sleeve is designed without a socket for the shoulder, and in turn creates a deep and wide armhole that reaches from the waist to a narrowed wrist.

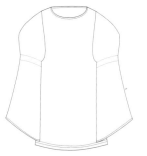

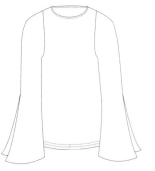

LEG-OF-MUTTON

First seen on garments as far back as 1824, the leg-of-mutton sleeve is cut to have fullness or gathers at the top of the sleeve narrowing towards the cuff.

CAPPED

The capped sleeve is cut with a small sleeve head or cap at the top of the shoulder. It's usually seen on summer garments for warm weather.

PUFFED

Puffed sleeves have a youthful look, sometimes seen in childrenswear or teenager's clothing. The puffed sleeve length can be cut long or short.

ADJUSTABLE

The adjustable sleeve can be worn with either a long or short sleeve length. The functioning tab can be used to adjust the length of the sleeve.

KIMONO

The kimono sleeve is a wide sleeve, cut in one piece from the front and back of the garment. It is seamed down the outer and under arms, like a traditional Japanese kimono.

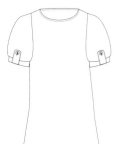
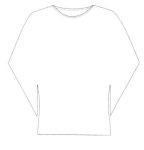

COAT AND JACKET • SLEEVES

Outerwear sleeves can be varied in length and style and will generally be made in a slightly thicker fabric. Consideration for the function of your sleeve is essential in your design.

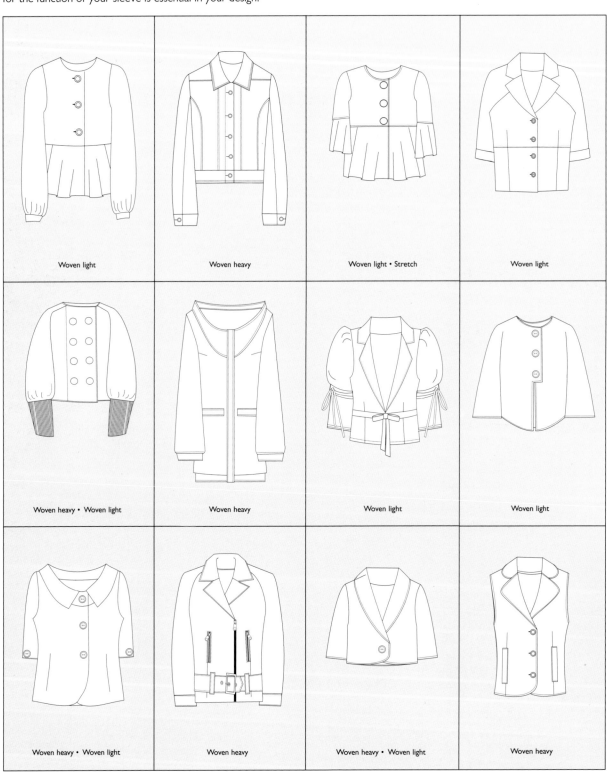

Woven light	Woven heavy	Woven light • Stretch	Woven light
Woven heavy • Woven light	Woven heavy	Woven light	Woven light
Woven heavy • Woven light	Woven heavy	Woven heavy • Woven light	Woven heavy

This selection of photographs represents some of the many possibilities to consider when you are designing your outerwear sleeves. Think about the length of your sleeve, and the fabric and fit of your garment, working in harmony.

1. Dropped-shoulder sleeve
A flowing dropped-shoulder cape sleeve in a heavyweight woven fabric with a collar and revere front.

2. Slit sleeve
A slit-sleeved jacket with a sexy nipped-in wrapover waist.

3. Dropped-shoulder sleeve
A three-quarter-length wide dropped-shoulder sleeve in a medium-weight woven fabric.

4. Set-in sleeve
A half-length set-in sleeved jacket with matching dress.

5. Set-in sleeve
A narrow set-in sleeve finished with shoulder pads and a nipped-in waistline that gives an updated eighties look.

6. Slit sleeve
A wide slit-sleeved knee-length jacket made in leather.

7. Set-in sleeve
An elegant set-in sleeve on a double-fronted jacket made in a medium-weight woven fabric.

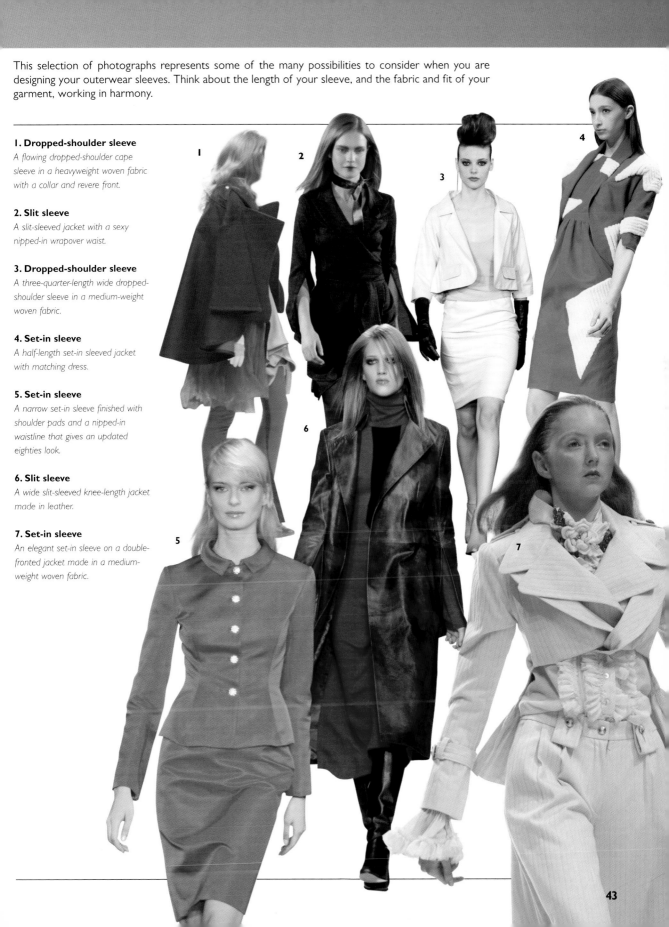

COAT AND JACKET • SLEEVES (CONTINUED)

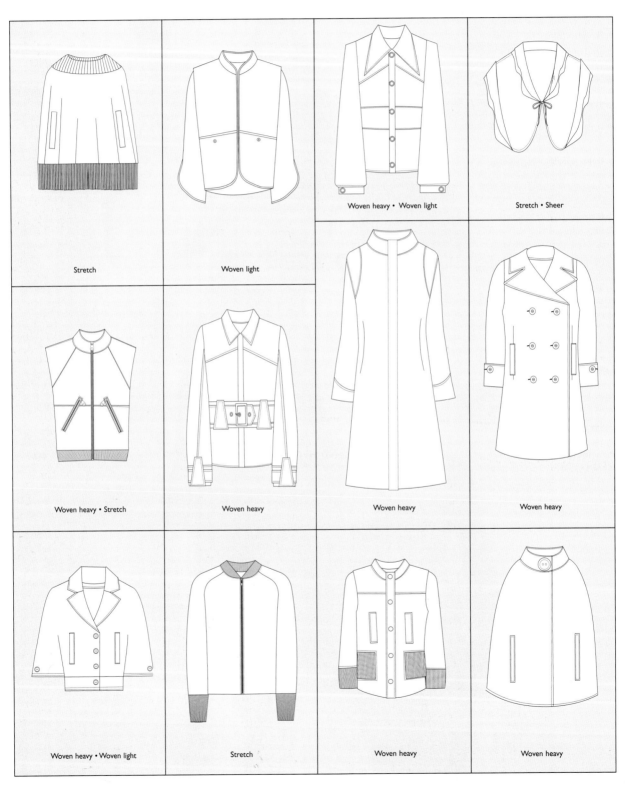

Stretch

Woven light

Woven heavy • Woven light

Stretch • Sheer

Woven heavy • Stretch

Woven heavy

Woven heavy

Woven heavy

Woven heavy • Woven light

Stretch

Woven heavy

Woven heavy

1. Dropped shoulder
A wide jacket with an exaggerated dropped shoulder.

2. Pleated slit sleeve
An original sleeve idea with a dramatic effect as the pleats are extended to the sleeves.

3. Raglan sleeve
A raglan-sleeved jacket with a padded round shoulder.

4. Fitted dropped shoulder
The traditional raincoat has been updated with a play on details and proportions.

5. Raglan sleeve
A wide-sleeved coat with a raglan shoulder and turned-up cuffs.

6. Dropped shoulder
A wearable dropped-shoulder sleeved jacket.

7. Cape sleeve jacket
A cape sleeve in dark wool creates this theatrical jacket.

8. Flared sleeve
A flared sleeve creates volume and interest on this plain-fronted jacket.

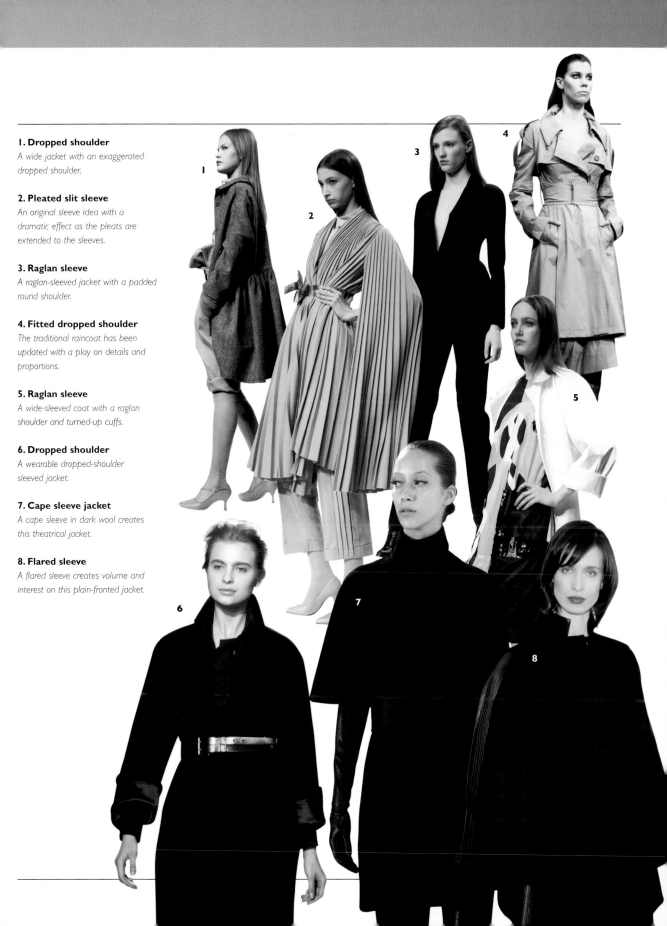

TOP • LONG SLEEVES

Long-sleeved tops are wardrobe staples and are likely to be influenced by recent fashion trends. The style of sleeve should complement the rest of the garment.

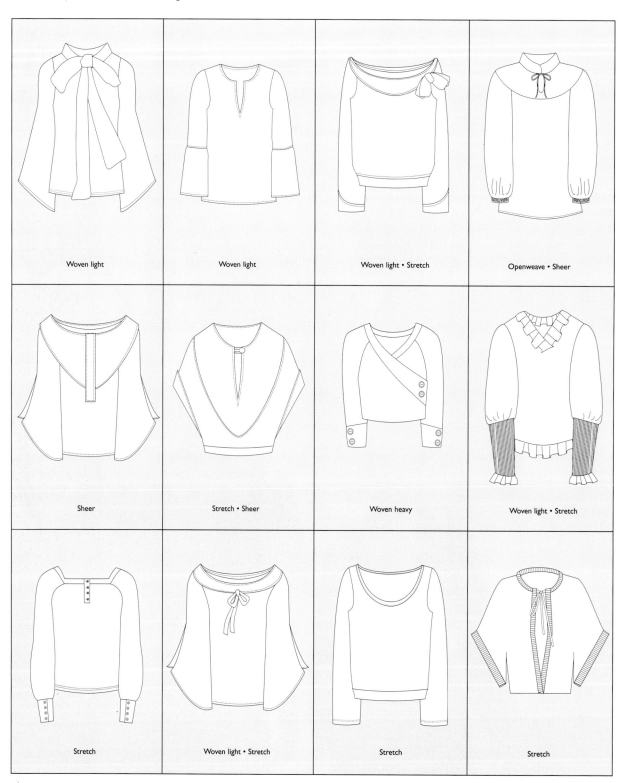

Woven light	Woven light	Woven light • Stretch	Openweave • Sheer
Sheer	Stretch • Sheer	Woven heavy	Woven light • Stretch
Stretch	Woven light • Stretch	Stretch	Stretch

This selection of sleeves will give you an idea of the possibilities on offer. Think about your fabric and consider its capabilities and limitations. Design with the whole of your garment in mind as well as the complete finished look.

1. Bishop sleeve
The bishop sleeve with a gathered cuff sits under an exaggerated shoulder cape detail.

2. Set-in sleeve
A set-in sleeve with a layering detail gives a romantic feel to this eveningwear top made from sheer fabric.

3. Bishop sleeve
A flowing cuffed, dropped-shoulder bishop sleeve made in medium-weight woven fabric.

4. Fitted dolman sleeve
A 1980s inspired tightly fitted dolman-sleeved top. Made in jersey fabric with exaggerated shoulder padding.

5. Saddle sleeve
A three-quarter-length saddle sleeve with a small slit opening made in a stretch fabric.

6. Bishop sleeve
A loose fitting bishop sleeve with gathering at the wrist, made in a medium-weight woven fabric with good drape.

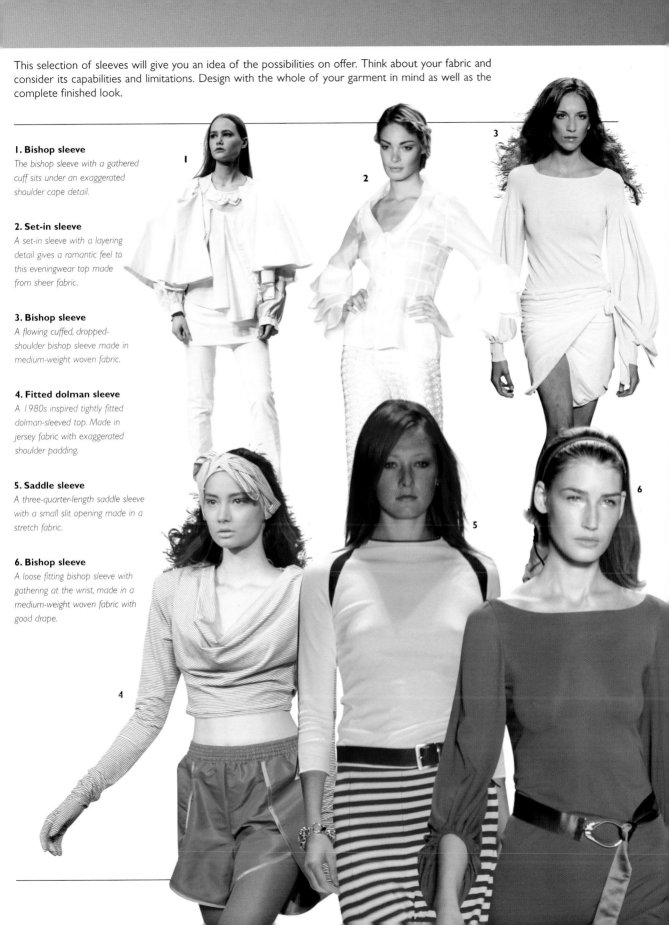

TOP • SHORT SLEEVES AND SLEEVELESS

Short-sleeved tops tend to be made in medium-weight, sheer or stretch fabrics. Consider creating an interesting décolletage, feminine sleeves or striking fabric contrasts and colour combinations.

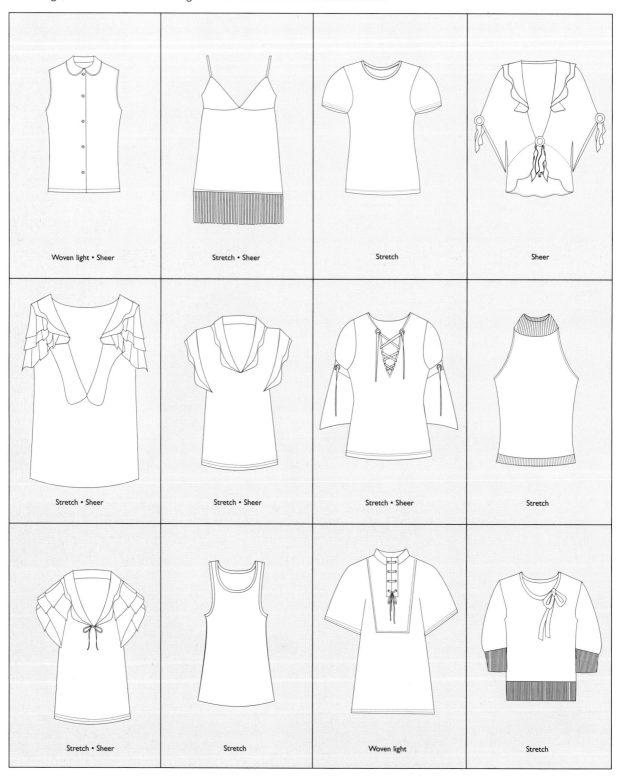

Woven light • Sheer	Stretch • Sheer	Stretch	Sheer
Stretch • Sheer	Stretch • Sheer	Stretch • Sheer	Stretch
Stretch • Sheer	Stretch	Woven light	Stretch

Your top will need to reflect some kind of research influence and should to be in keeping with the look of your outfit and capsule collection. Think about the balance of details on your garment and don't over do it. Remember, less is more.

1. Sleeveless top
This period-inspired outfit has a striking neckline that is also echoed on the hem of the garment.

2. Frill sleeves
A double-layered frill short-sleeved top is worn under a cropped pinafore.

3. Capped sleeves
Exaggerated capped sleeves with shaped shoulder pads give this top a striking look.

4. Frill sleeves
An open neck and playful frill sleeves give this top a feminine appeal.

5. Dropped-shoulder sleeve
A simple round neck is offset by the understated short dropped-shoulder sleeves made in a sheer fabric.

6. Dolman sleeve
A flattering deep V-neck and fitted waist are offset by half-length dolman sleeves.

7. Dropped-capped sleeve
This wide A-line top is finished with dropped-cap sleeves in a floaty sheer fabric.

8. Frill sleeves
Small frill sleeves complete the look for this full A-line top made in layers of sheer fabric.

9. Oversized puffed sleeve with turn back
This dramatic look has been created by oversizing the humble puffed sleeve. Made from a stiff medium-weight fabric to carry the design.

10. Kimono sleeves
Half-length kimono sleeves work well on this graphic outfit. The fabric has good drape, which fits the design.

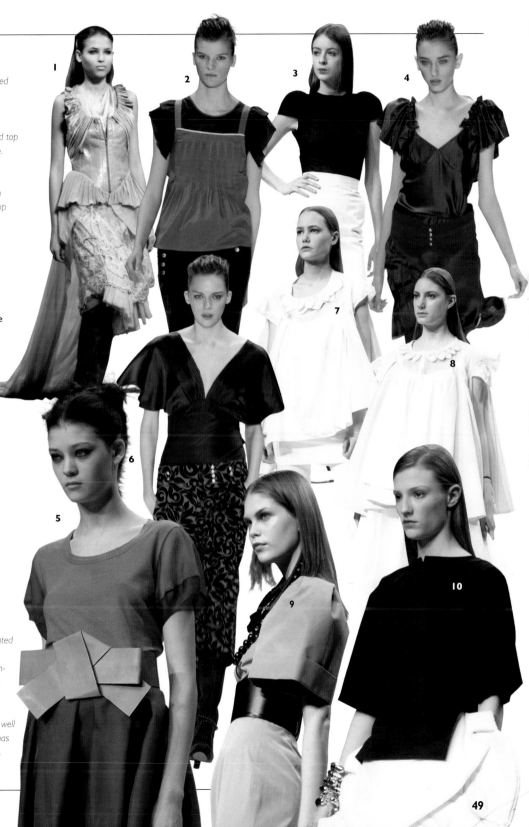

DRESS • SLEEVES

Dress sleeves can be varied and should be functional. Think about what is happening on the rest of the dress and how your sleeves should be designed to complement the overall look.

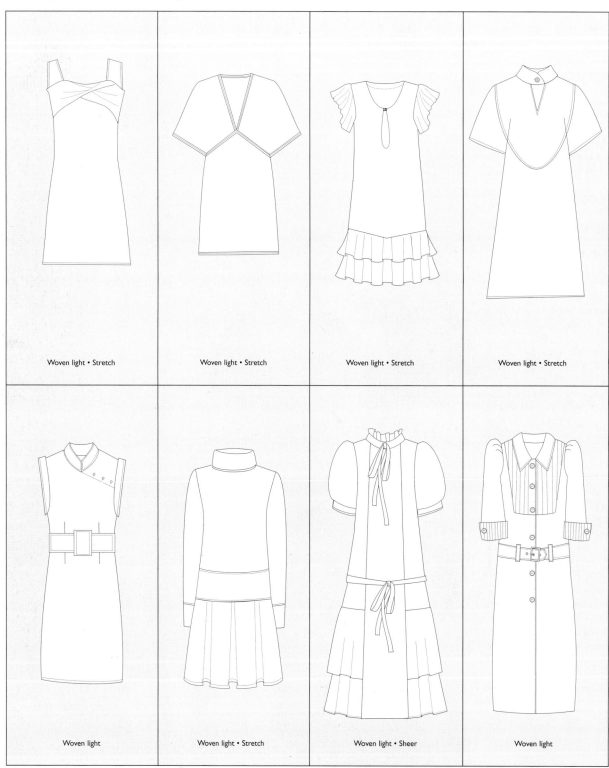

Woven light • Stretch

Woven light • Stretch

Woven light • Stretch

Woven light • Stretch

Woven light

Woven light • Stretch

Woven light • Sheer

Woven light

Dress sleeves can vary in length and style. Consider the occasion the dress is being designed for, which could be daywear, eveningwear or work. Your style of sleeve should also reflect the rest of the capsule collection.

1. Side-slit set-in sleeve

A formal sleeve has been given an alluring style detail with the side-slit opening and cuffed wrist.

2. Dropped-shoulder bishop sleeve

The flowing fabric adds an extra dimension to this minimal dress. The sleeve is a dropped-shoulder bishop with a gathered cuff.

3. Cut-away shoulder

This dramatic sleeve is achieved by cutting away to reveal the shoulder.

4. Dolman sleeve

The simplicity of this shift dress is reflected in the wide-cuffed sleeves.

5. Half-length batwing sleeves

The half-length batwing sleeves merge into the draped neckline of this 1940s-inspired dress to give a striking finish.

6. Three-quarter-length gathered set-in sleeve with cuff

The design simplicity of the dress complements the print, which is the main focal point of this daywear outfit.

7. Frill sleeve

In a black transparent fabric, this revealing sleeve teases the eye and forms part of the front of the dress as the gathers frame the neckline.

8. Saddle sleeve

The black piping is used to finish and highlight the main style lines on this day dress, giving a very graphic look.

9. Fitted set-in sleeve

This formal dress has fitted three-quarter-length sleeves that complement the overall look. The step cuff detail is also echoed on the hem.

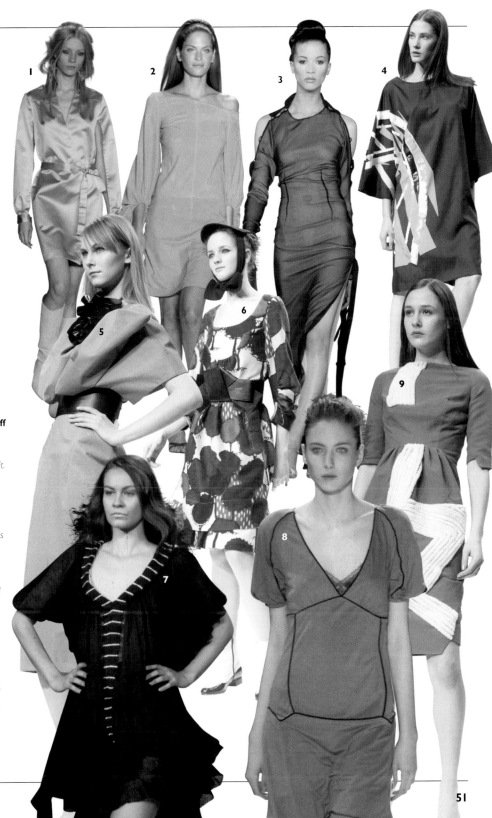

KNITWEAR • SLEEVES

The many different yarn plys from fine to chunky and the myriad stitch textures create a huge potential range of sleeve styles and designs.

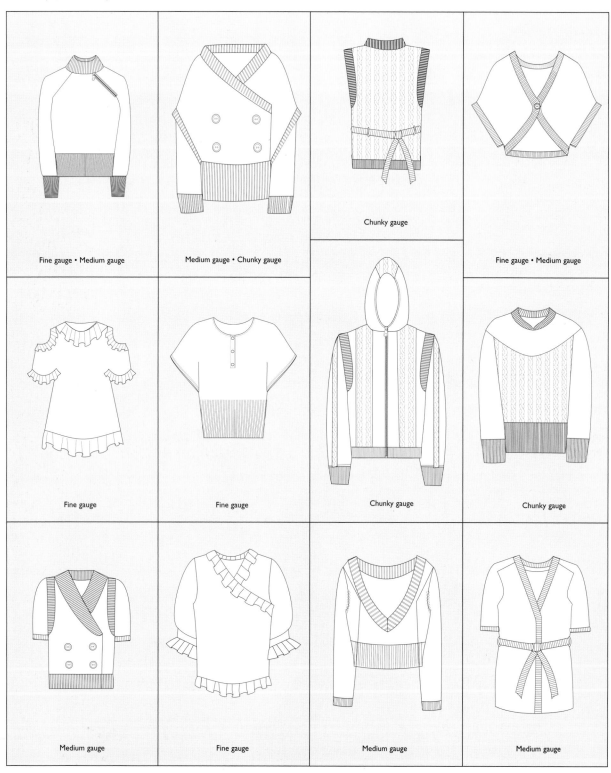

Fine gauge • Medium gauge	Medium gauge • Chunky gauge

Chunky gauge

Fine gauge • Medium gauge

Fine gauge

Fine gauge

Chunky gauge

Chunky gauge

Medium gauge

Fine gauge

Medium gauge

Medium gauge

The choices of knitwear sleeves are vast. Knitwear is more pliable than woven fabrics, so there is more scope to be creative in your design. Design with your yarn and colour palette in mind and keep the sleeves functional.

1. All-in-one cut away

These sleeve are made in one continuous knitted fabric, which also incorporates a draped neckline.

2. Exaggerated puffed sleeve

This cut-and-sew knitwear dress has exaggerated puffed sleeves that work to dramatic effect because of the stiffness of the fabric.

3. Double-layer frill sleeve

A wearable knitwear sweater with double-layer frill sleeves that give added feminine appeal.

4. Raglan sleeve

A raglan-sleeved dress with contrasting colours on the neckline and sleeves.

5. Capped sleeve

A sexy top finished with capped sleeves and a round neckline.

6. Set-in sleeve with gathers

A simple polo-necked top with long set-in sleeves and gentle gathers at the head of the sleeve.

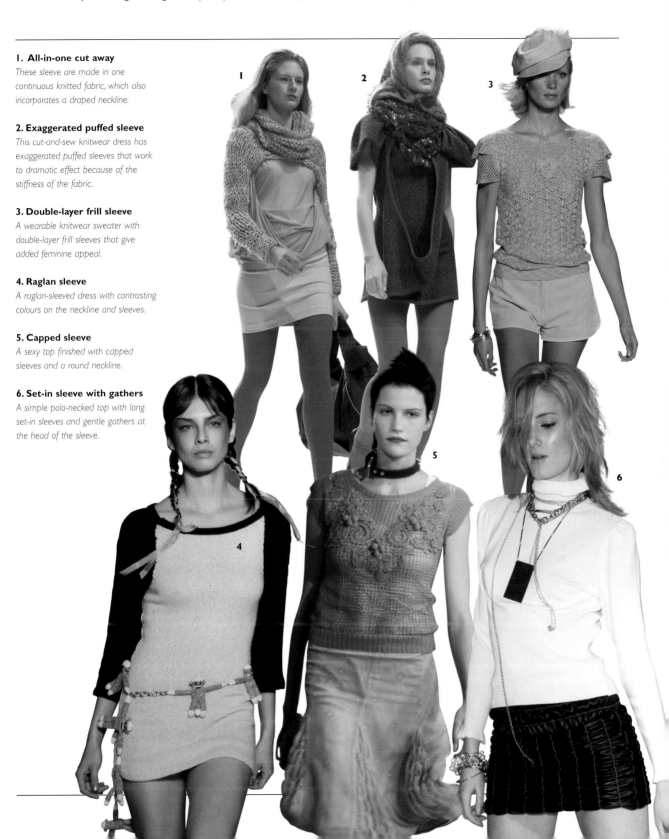

NECKLINES AND COLLARS

NECKLINES

Necklines complement the shape of the wearer's face, neck, décolletage and shoulder area by balancing out individual features with the style of the garment. A round face is well framed by a plunging neckline and an angular one softened by a curved or gentle neckline.

Necklines have the power to influence the mood and style of a garment. A plunging neckline can look extremely sexy whereas a small rounded neckline suggests an air of casual modesty. A garment's neckline is constantly in view so it needs to be given careful consideration. The nature of your research and choice of fabric will certainly influence your selection.

The following pages show you the necklines and neckline variations most commonly used in fashion. Consider how much the style of a neckline can affect the final statement of a finished garment. While most necklines contribute to the interest of the general design, in some cases they can be its main feature.

V-NECK

This most popular and classic of necklines has a design that works with most fabrics and can be seen on a variety of upper-body items.

INSET NECK

A variation on the V-neck, it offers the possibility for a lower V-shape while retaining a sense of modesty.

DÉCOLLETAGE

This feminine neckline usually works best in woven fabrics and can be seen on tops and dresses.

SWEETHEART

This feminine design is good for accentuating a wearer's décolletage. A combination of the V-neck and square neck frames the neck and shoulder area.

SQUARE NECK

A popular and versatile neckline that works well in a variety of fabrics.

U-NECK

A variation on the square neck, the simple lines of this neckline will suit most people.

ROUND NECK

With simplicity as its main feature, this classic neckline has stood the test of time and is transferable between a variety of woven and stretch fabrics.

BOAT-NECK

This sweeping neckline shape reveals a little of the shoulder area.

ENVELOPE

This simple neckline has fabric crossing over as a detail on the shoulder.

SLASH

This shape of neckline creates a straight line that cuts directly across the shoulders and sits on the collarbone.

SCOOP

The sweeping, curvy lines of this neckline cut across the neck area and dip low at the front.

HORSESHOE

This wide neckline dips at the front to accentuate the décolletage and neck area.

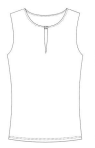 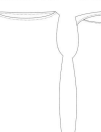 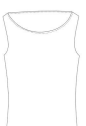 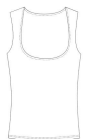

 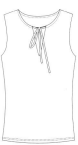 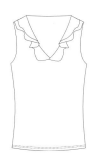 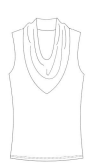 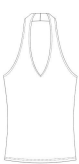

KEYHOLE

This laidback style of neckline works well on both sportswear and casual attire.

DRAWSTRING

Usually associated with informal and sporty clothing, this design has a relaxed look and works equally well in both woven and stretch fabrics.

FRILL

This pretty and versatile neckline can sometimes be seen on knitwear but also works well with woven fabrics. Vary the scale and density of the frills to add variety and interest.

DRAPE

The excess material around the neckline results in a fabulous drape neckline that is ideal for eveningwear that is sexy but not too revealing.

FUNNEL

This shape is created by extending the normal neckline to create a funnel that gently rests at the base of the neck.

HALTERNECK

This type of neckline design proposes a single strap around the back of the neck instead of one strap over each shoulder. Seen on tops and dresses and occasionally on swimwear, this plunging neckline is most suited to spring or summer items as it leaves the shoulder area and back bare.

COLLARS

Dating back as early as the thirteenth century, a collar is the part of a shirt, blouse, jacket, dress or coat that encircles the neck. Traditionally worn upright or turned over the neckline, and once only associated with men's clothes, collars were originally designed as removable inserts in a garment.

A collar's appearance is defined by the shape of the neckline to which it is attached. Fashion items from different historical periods, and even decades, can be dated accurately by the shape of the collar. Ruffles, for instance, instantly bring to mind Shakespeare and Elizabethan England, whereas oversized triangular collars and lapels recall clothes worn in the 1970s.

Collars are major focal points and finish off garments by decorating, complementing or emphasizing the neckline. They can also easily reveal the source of a designer's inspiration. Today's eclectic sense of fashion means that collars come in an array of styles – from flouncy ruffles, stiff Napoleon-style stand necks, crew necks and turtlenecks to wide fur lapels, shawl collars or even futuristic, funnel-like neckpieces.

These two pages name and describe the most common types of collars. Consider how the style can affect the overall balance of a finished piece. While most collars add interest to the overall design, they can in some cases be a garment's main feature.

BAND
This style of collar stands up around the neck with an opening.

MANDARIN
Originally worn by Chinese aristocracy, this small standing collar with rounded edges has a front opening.

BOW
The main feature of this feminine collar are two front ties that form a pretty bow when tied together.

BISHOP
Originally borrowed from a clergyman's garb, this versatile collar has an air of formality and austerity about it.

SQUARE BERTHA
A deep square, cape-like collar. Usually attached to a simple round neckline giving an interesting contrast of shapes.

ROUND BERTHA
This cape-like collar is best worked in a woven fabric.

HENLEY

Sometimes seen on jersey or woven garments, this popular shallow collar band has a button placket.

POLO

This simple collar style has a front button placket.

SHIRT

Popular and functional, this classic collar is seen mostly on woven fabrics.

STAND

This single layer collar stands up from the neckline without folding over.

FRILL

The most feminine type of collar – ruffles decorate the neck in gentle, flowing lines that soften the face.

CREW NECK

A simple round-necked collar usually made from a stretch fabric that allows it to be pulled over the head.

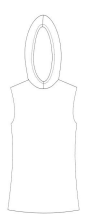

HOOD

Often seen on sportswear or casualwear, this covering for the head is attached to the neckline of the garment.

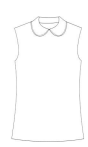

PETER PAN

Sometimes seen on children's clothing, women's shirts and coats, this playful, youthful collar consists of a small, flat round-cornered collar without a stand.

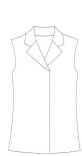

COLLAR AND REVERE

Traditionally derived from men's tailoring, the collar and revere is a popular style for coats and jackets. Width variations on the collar and revere change from season to season.

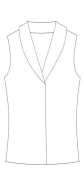

SHAWL

Most commonly seen on jackets, coats and knitwear, this soft-looking collar is often grown from the main part of the garment.

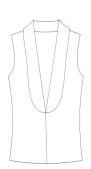

TUXEDO

Derived from menswear and similar in appearance to the shawl, it has a deep V-neck and a more rounded collar.

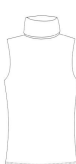

ROLL-NECK

Usually made from a stretchy fabric, this close-fitted tubular collar allows the garment to be pulled over the head and will emphasize a long, graceful neck.

COAT AND JACKET • NECKLINES AND COLLARS

Necklines and collars are a main focal point on outerwear garments. As fabrics for coats and jackets tend to be thicker, think about the type of finish your fabric is capable of.

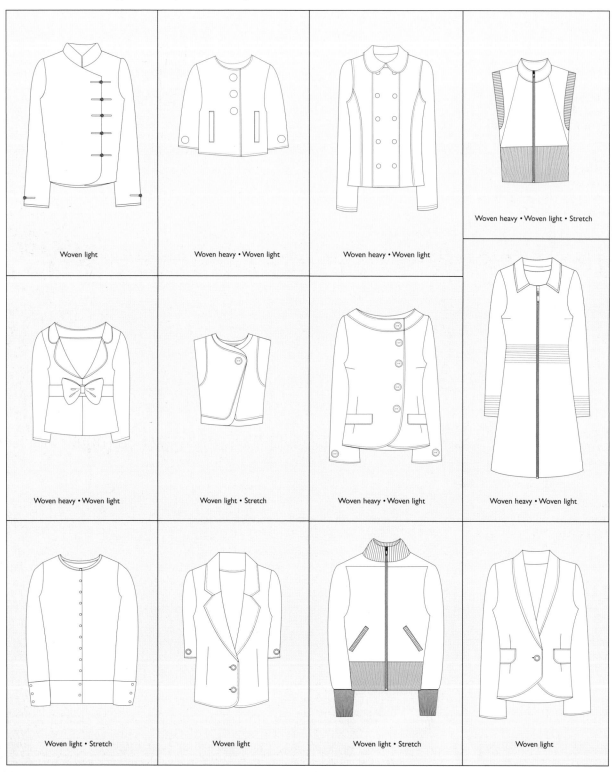

Woven light

Woven heavy • Woven light

Woven heavy • Woven light

Woven heavy • Woven light • Stretch

Woven heavy • Woven light

Woven light • Stretch

Woven heavy • Woven light

Woven heavy • Woven light

Woven light • Stretch

Woven light

Woven light • Stretch

Woven light

Outerwear garments may be worn for a few autumn/winter seasons – think about how fashions might change. Carry some research influence through, and think about whether the neckline fits the mood of the rest of the capsule collection.

1. Button-up collar
This collar has a button stand which, when done up, will provide extra protection and comfort for the neck and face.

2. Collar without stand
A formal and simple finish to this fitted coat made in a heavyweight woven fabric.

3. Shawl collar
The shawl collar works well in soft knitted fabrics and gives this jacket a casual and wearable appeal.

4. Collar without stand
A bold-print jacket has a simple collar without stand that complements the overall design.

5. Collar without stand
A standless collar adds a casual elegance to this leather jacket.

6. Mandarin-collar
This geisha-inspired jacket has a mandarin-style collar with an asymmetric revere.

7. Button-front standing collar
The jacket has a tall button-front, standing collar that accentuates and frames facial features.

8. Collar and stand with crossover front
A different look is achieved when the collar is made from layers of soft woven fabrics.

9. Button and collar
This sculptural jacket has a simple button and collar front.

10. Shirt collar
A bold shirt collar with a button tab.

COAT AND JACKET • NECKLINES AND COLLARS (CONTINUED)

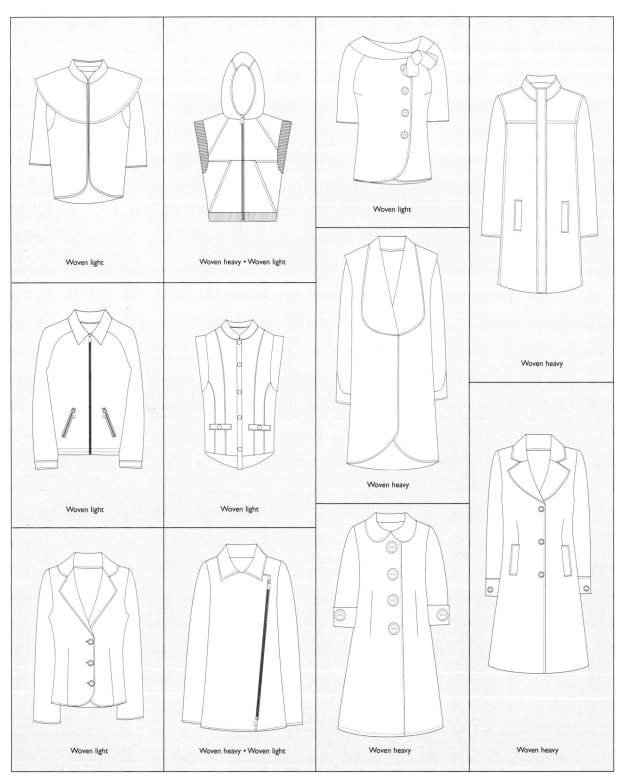

Woven light

Woven heavy • Woven light

Woven light

Woven light

Woven light

Woven light

Woven heavy • Woven light

Woven light

Woven heavy

Woven heavy

Woven heavy

Woven heavy

1. Collar and revere
A wide collar and revere has been finished with a contrasting satin focal point.

2. Collar
A collar with a front zip.

3. Collar without stand
A simple standless collar gives a striking look when seen in bright red.

4. Collar without stand
In jersey, the standless collar has a feel of relaxed chic.

5. Grown on collar
A chic collar that emerges from the main body of the garment and gathers gently round the neck.

6. Button and collar
A simple button and collar on a black woollen coat with additional decoration.

7. Standing collar
A dramatic silhouette is created by this standing collar that has been finished with rows of topstitching.

8. Collar and revere
The collar and revere has new sexiness as part of this sharply tailored jacket.

9. Peter Pan collar
A fitted tailored jacket with a Peter Pan collar and a double-front detail complete this very wearable jacket.

SHIRT AND BLOUSE • NECKLINES AND COLLARS

Depending on the intended look of your finished garment, explore the variety of possible shirt and blouse collars. Think about balancing your garments details so they complement each other.

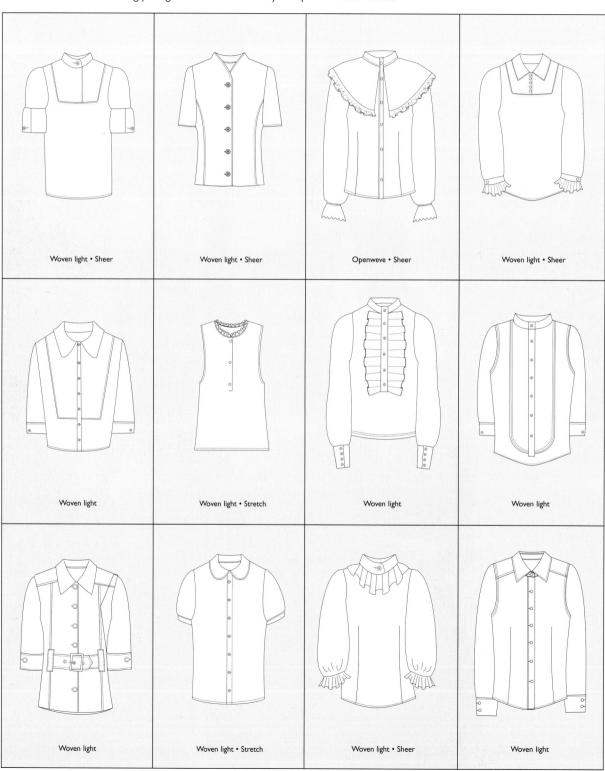

Woven light • Sheer	Woven light • Sheer	Openweve • Sheer	Woven light • Sheer
Woven light	Woven light • Stretch	Woven light	Woven light
Woven light	Woven light • Stretch	Woven light • Sheer	Woven light

Collars and necklines are focal points on garments with which you can let your creative flare shine through. Be as bold as you dare or as minimal as you want. Your shirt and blouse collars and necklines are vital details and integral to the whole of the capsule collection.

1. Round neck
This bold-print blouse has a simple and minimal rounded neckline.

2. Shirt collar
A sharply tailored shirt in white cotton has a slightly raised shirt collar and stand.

3. Multi-collar
In keeping with the rest of the design, the collar has been multiplied and becomes an interesting detail in its own right.

4. Gathered collar
The gathering at the neckline on this collar softens the whole look of this satin shirt.

5. Frill collar
An oversized frill collar creates attention and a focal point for this sexy blouse.

6. Off-the-shoulder collared neckline
A provocative neckline that falls off the shoulder and is framed by a collar.

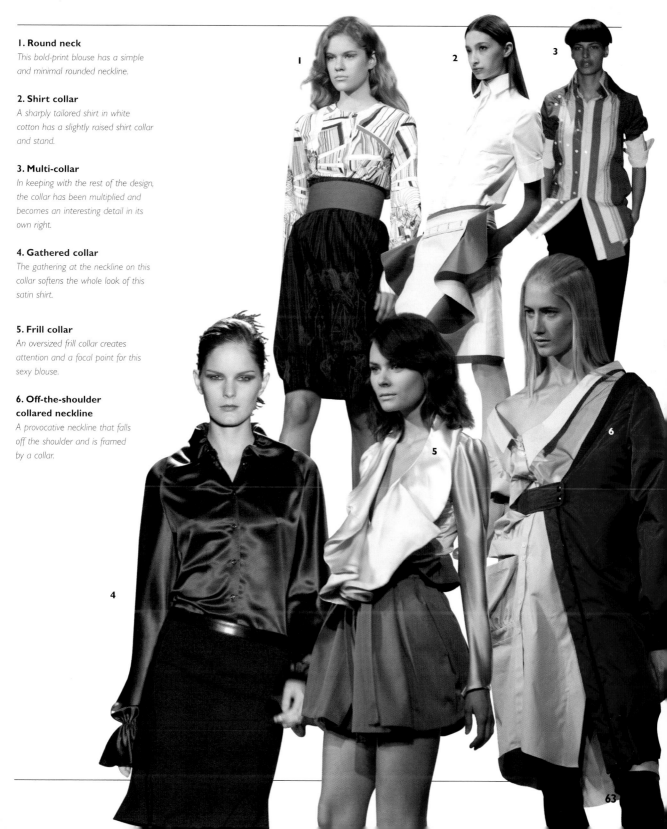

TOP • NECKLINES AND COLLARS

Likely to be subject to recent fashion influences, top necklines are varied and the choice is vast. For the most effective results, consider influences, fabric choice and colours.

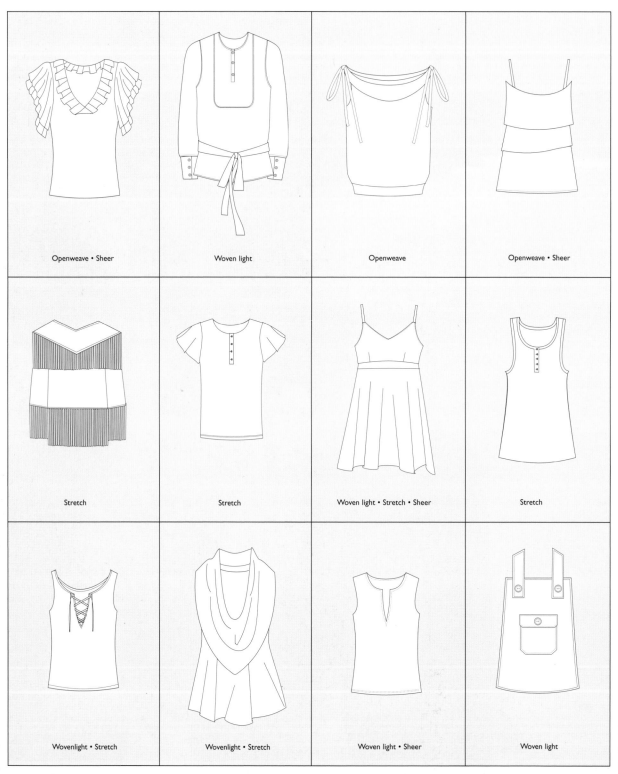

Openweave • Sheer	Woven light	Openweave	Openweave • Sheer
Stretch	Stretch	Woven light • Stretch • Sheer	Stretch
Wovenlight • Stretch	Wovenlight • Stretch	Woven light • Sheer	Woven light

Top necklines can create numerous effects – anything from theatrical to sexy. Think about influences from your research and the type of fabric you are using to help you achieve a successful neckline that will contribute to the rest of your capsule collection.

1. Boat-neck
This graphic top has been finished with a simple, paired-down boat-neck.

2. Bertha collar
A small Bertha collar has been added to this austere top that hints at an ecclesiastical influence.

3. Open-neck roll collar
Open-neck top with a roll-down collar completes this top made in a sleek satin fabric.

4. Collar and placket
This jersey top is simply finished with the classic placket and collar neckline.

5. Roll-neck
A knitted roll-neck top will give the illusion of a lengthened neck, and frame the face.

6. Bow-collar neckline
This combination collar works well to serve its purpose of highlighting the face and neck area.

7. Crew neck
A high crew neck collar made from a lightweight woven fabric and finished with a pintucked front.

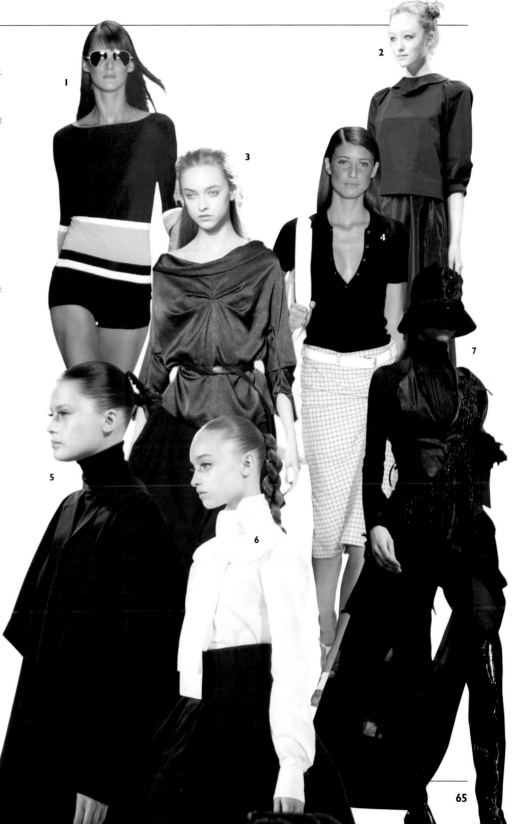

TOP • NECKLINES AND COLLARS (CONTINUED)

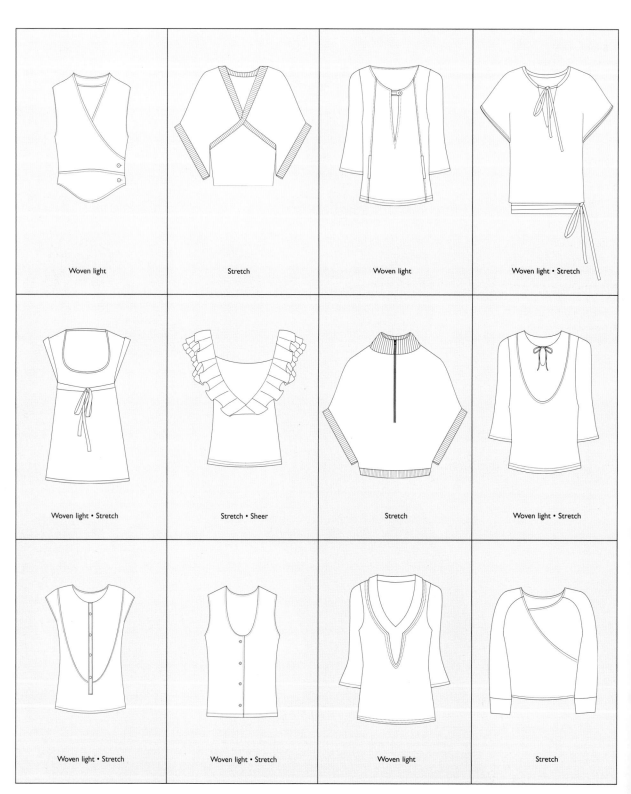

Woven light

Stretch

Woven light

Woven light • Stretch

Woven light • Stretch

Stretch • Sheer

Stretch

Woven light • Stretch

Woven light • Stretch

Woven light • Stretch

Woven light

Stretch

1. Décolletage

A feminine décolletage neckline made from layers of lightweight chiffon gives this top daring appeal.

2. Scoop-neck

A scoop-neck that has been finished with a collared band gives this top an understated yet sexy neckline.

3. Boat-neck

A boat-neck completes this top made in a sheer stretch fabric.

4. Round neck

A simple round neck with added gathers at the front give this neckline a new appeal.

5. Banded halterneck

A halter neckline with a neckband frames the face and shoulder area with great effect.

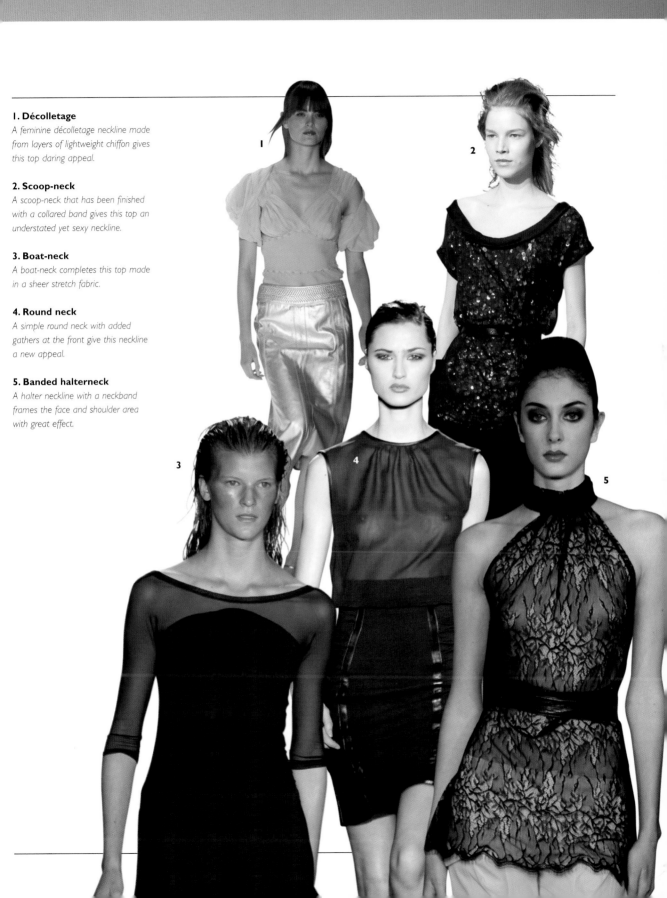

TOP • NECKLINES AND COLLARS (CONTINUED)

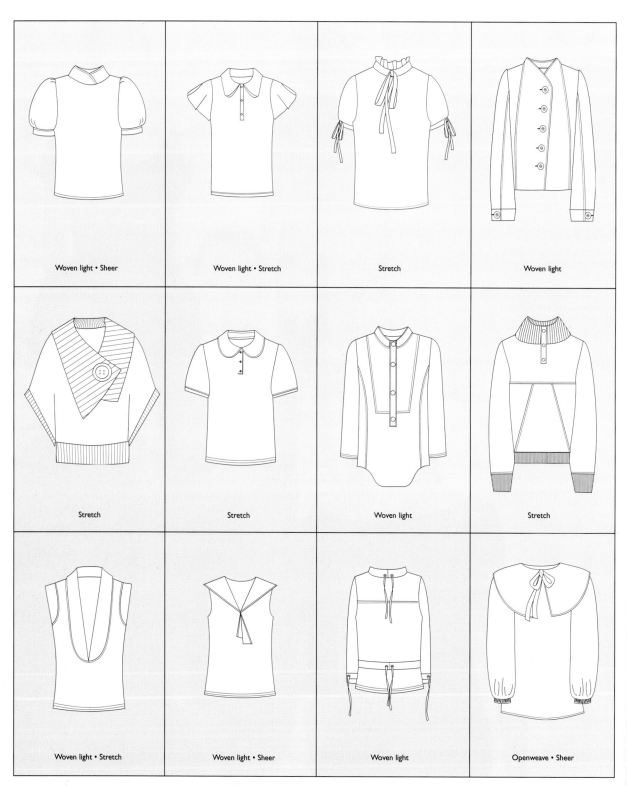

Woven light • Sheer

Woven light • Stretch

Stretch

Woven light

Stretch

Stretch

Woven light

Stretch

Woven light • Stretch

Woven light • Sheer

Woven light

Openweave • Sheer

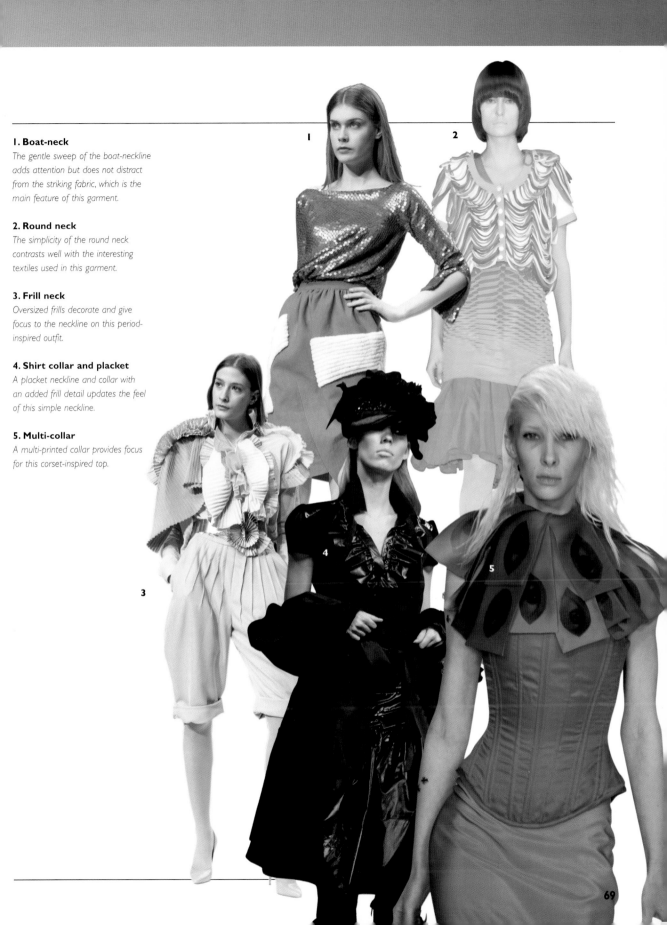

1. Boat-neck
The gentle sweep of the boat-neckline adds attention but does not distract from the striking fabric, which is the main feature of this garment.

2. Round neck
The simplicity of the round neck contrasts well with the interesting textiles used in this garment.

3. Frill neck
Oversized frills decorate and give focus to the neckline on this period-inspired outfit.

4. Shirt collar and placket
A placket neckline and collar with an added frill detail updates the feel of this simple neckline.

5. Multi-collar
A multi-printed collar provides focus for this corset-inspired top.

DRESS • NECKLINES AND COLLARS

Necklines and collars decorate and frame the shoulders and face. When designing, consider your design influences and the capability of your fabrics, and focus on the look you aim to achieve for your final garment.

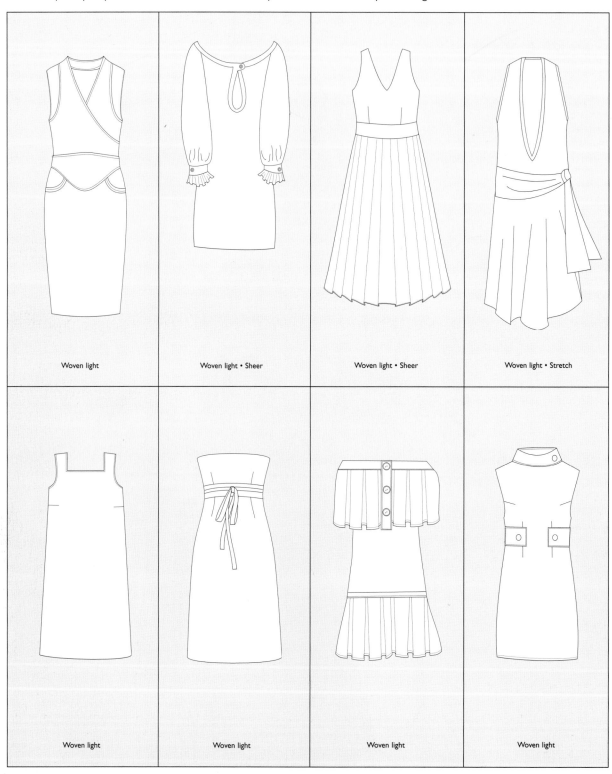

| Woven light | Woven light • Sheer | Woven light • Sheer | Woven light • Stretch |

| Woven light | Woven light | Woven light | Woven light |

The neckline can provide you with the scope to be daring and creative, or simple and modest. The neckline on dresses forms a natural focal point for the eye, so be aware that whatever you decide on, it will constantly be on view. Carry research influence through to inform your design decisions.

1. V-neck
Two straps make a prominent V-neck. This revealing neckline is popular for eveningwear and summer day dresses.

2. Organic neckline
This organic neckline has been developed by draping on the dress stand.

3. U-neck
A revealing deep U-shaped neck on this dress creates a daring focal point.

4. Banded halterneck
Made from crepê fabric, this dress has a plunging neckline with the shoulders and back exposed.

5. Sweetheart neckline
A sleeveless dress with a simple sweetheart neckline.

6. Boat-neck
This minimal dress is completed with a simple boat-neckline.

7. Collared round neck
This oversized dress has been completed with a sweet collared round neck that is bordered by frills.

8. Oversized box frills
This neckline is made in a stable heavyweight woven fabric that holds its shape.

9. Sweetheart neckline
A clean two-strap sweetheart neckline that shows off the neck, shoulder and back area.

10. Halterneck
A striking red halterneck dress, with a daring deep V-neck at the front.

11. Square neck
A two-strap dress with a square neckline accentuates the shoulders.

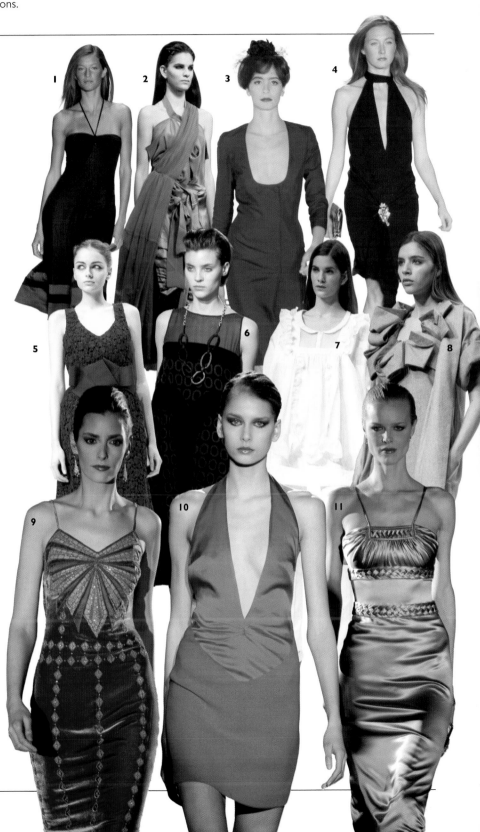

KNITWEAR • NECKLINES AND COLLARS

Knits are a very pliable and creative fabric to use. Consider how your colour palette and knitted pieces will complement the rest of your capsule collection.

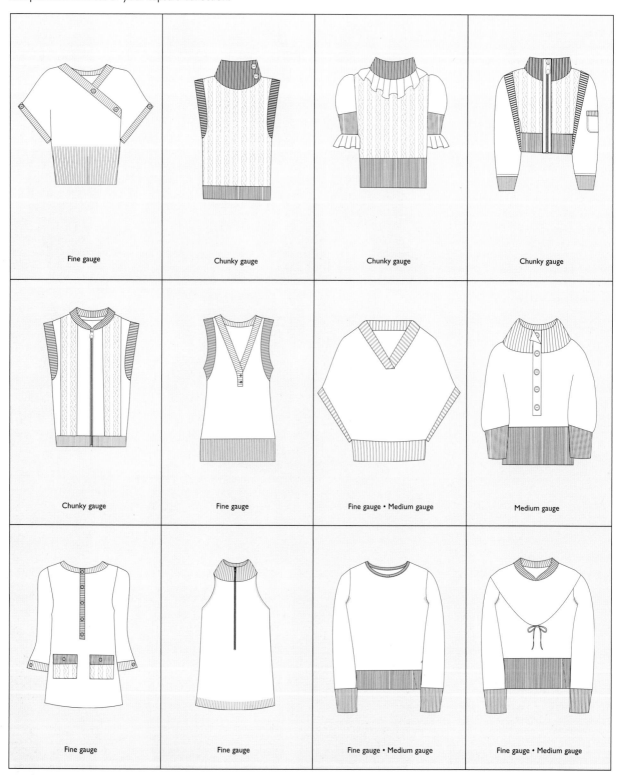

Fine gauge	Chunky gauge	Chunky gauge	Chunky gauge
Chunky gauge	Fine gauge	Fine gauge • Medium gauge	Medium gauge
Fine gauge	Fine gauge	Fine gauge • Medium gauge	Fine gauge • Medium gauge

Knitted necklines and collars can be varied, inspired and daring. A simple collar seen in a new fabric is suddenly given a new lease of life. Try to push the boundaries with exciting styles for your knitted necklines.

1. Round neckline
A round neckline has been framed by graduating colour, which adds focus and attention.

2. Square neckline
A two-strap knitted dress that creates a square neckline is worn over a plain white T-shirt.

3. V-neck front
Graphic colours dominate this Mondrian-inspired knitted dress, with a minimal crossover front.

4. Ribbed shawl collar
This cropped cardigan has an enlarged collar with knitted ribbing.

5. Off-the-shoulder
A focal point has been created with a turn-down, off-the-shoulder neckline.

6. Keyhole neckline
An effortless keyhole neckline is given new life and focus with the use of bold and contrasting colours.

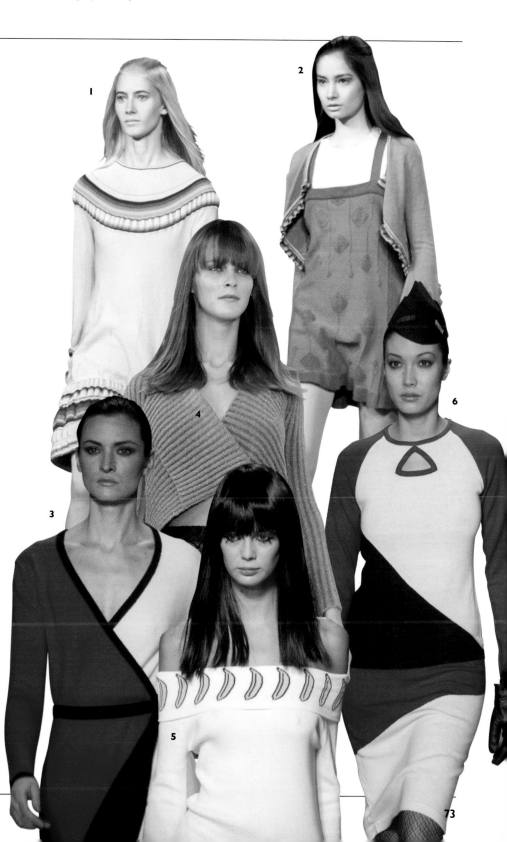

KNITWEAR • NECKLINES AND COLLARS (CONTINUED)

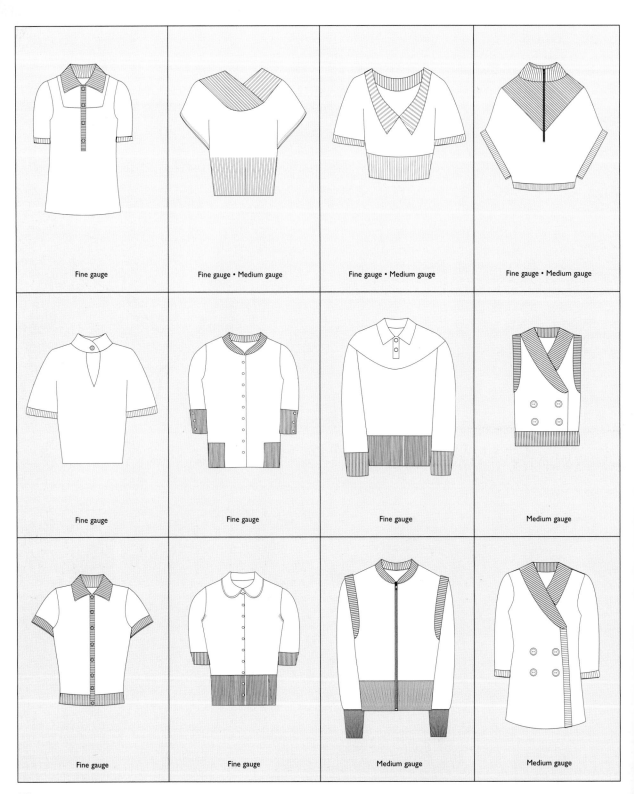

Fine gauge	Fine gauge • Medium gauge	Fine gauge • Medium gauge	Fine gauge • Medium gauge
Fine gauge	Fine gauge	Fine gauge	Medium gauge
Fine gauge	Fine gauge	Medium gauge	Medium gauge

1. Hood
This warm knitted hood provides a practical function – or a collar can be formed by wearing it down.

2. Ribbed collar
A casual ribbed collar adds slouch appeal to this knee-length cardigan.

3. Ribbed collar
A soft ribbed collar has been used on this short-sleeved cardigan.

4. Collar and revere
The traditional collar and revere is given a fresh look when seen in wide ribbed knitting.

5. Ribbed shawl collar
Large ribbing adds weight and interest to this front cross-over shawl collar.

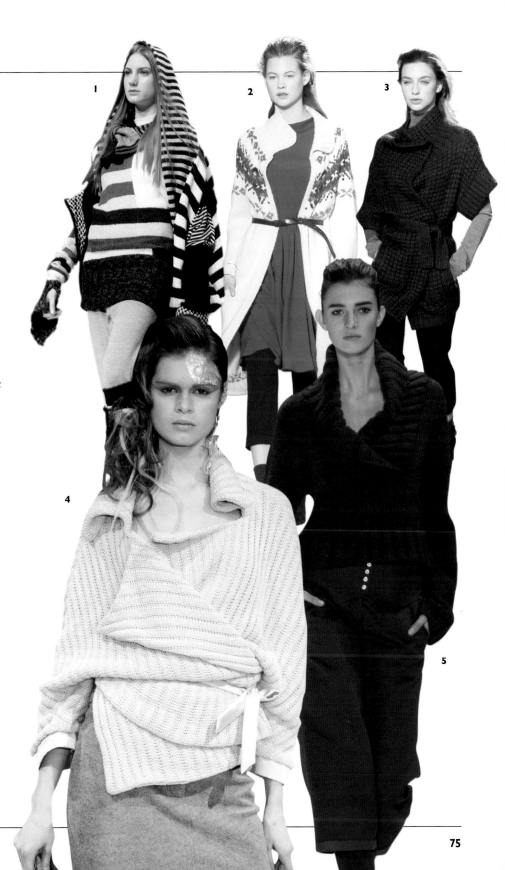

WAISTBANDS

Connotations of sexiness and femininity have been associated with the female waistline since the beginning of civilization. Past icons like Marilyn Monroe certainly knew how to emphasize theirs to maximum effect for a signature hourglass figure. As silhouettes have changed so has the placement of waistbands. The 1920s silhouette saw the dropped waist look which gave the female form a straighter, more boyish appearance. In the 1960s, the revival of the empire waistline, which sat just under the bust area, placed greater emphasis on the décolletage. Low-slung hipsters from the 1990s helped lengthen the upper body's silhouette. After years of creeping steadily south, the waistband has shot up high once again, making high-waisted trousers and denim hip.

Remember that waistbands have a practical function too, and usually some kind of opening allows the garment to be worn and fastened around the waist. An integral part of any garment, a combination of style, form and function needs to happen in the waistband region if a garment is to work successfully.

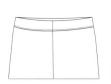

LOW WAIST

Low waists or "hipsters" were popularized in the 1990s, and their appeal continues today. The low waist sits on the pelvic area, elongating the upper body and revealing the top of the buttocks.

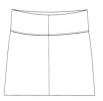

MEDIUM WAIST

The medium waist is one of the more comfortable styles to wear, with the waist sitting on the natural waistline.

HIGH WAIST

High waists are constantly in and out of fashion but have never entirely gone away. The high waist gives the female silhouette a smooth line over the hips and waist, emphasizing the bust area.

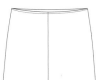

FACED

The faced waist has no waistband and is simply finished with a facing that hides away on the inside of the garment.

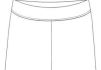

CURVED WAIST

The curved waist, used for trousers or skirts, puts emphasis on the abdomen.

ADJUSTABLE TABS

Adjustable side tabs are details that sit on the side of the waist area.

BELTED

The belted waist is a popular style for skirts and trousers. The waistband has belt loops through which a belt is passed to finish the look.

BUCKLE

Use the buckle-detailed waistband to adjust fit around the waist or as a design detail. The buckle detail can work on both the front and back of the garment.

FRONT TAB

The front tab waistband is often seen on tailored trousers and skirts. The front overlap usually has a fastening on the underside to hold the waistband securely in place.

WRAPOVER

The wrapover waistband gives the ideal finish for the wrapover skirt design. It works well with tailored or structured fabrics.

DRAWSTRING

The drawstring waistband is mostly used for casual trousers and sports-wear. The drawstring detail gives trousers a relaxed look and will work well with knit fabrics.

ELASTICATED

The elasticated waistband gives a gathered finish and is suitable for casual trousers or skirts in soft fabrics.

 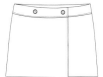 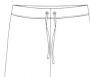

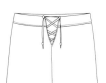 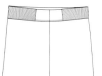 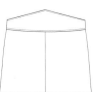 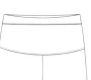 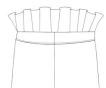

LACED

Reminiscent of lacing on a corset, this detail will work on the front, side and back of the waistband, and also acts as an opening.

RIBBED

The ribbed waistband can be fully ribbed or partly ribbed. The ribbing provides stretch and fit and is sometimes seen on children's clothing, clothing for the elderly, or sportswear.

SHAPED

The shaped waistband has a high-waist finish with a side-seam zip as the opening. This detail works well with tailored or structured fabrics.

YOKE

The yoke waistband is suitable for both trousers and skirts, with the darts taken out in the yoke seams and a side-seam zip for the opening.

PAPER BAG

The paper bag waistband has gathers at the waist. This type of detailing will work best with a stiff fabric.

PEPLUM

The peplum waist has a drape that begins at the waistband and sits around the hips, giving a feminine appeal to the garment. Choose a fabric that has good drape qualities.

SHORT AND TROUSER • WAISTBANDS

Waistbands provide a vital function for garments and are fundamental for skirt and trousers. Comfort and fit should be paramount and adding interest to the waist area will provide a focal point for your garments.

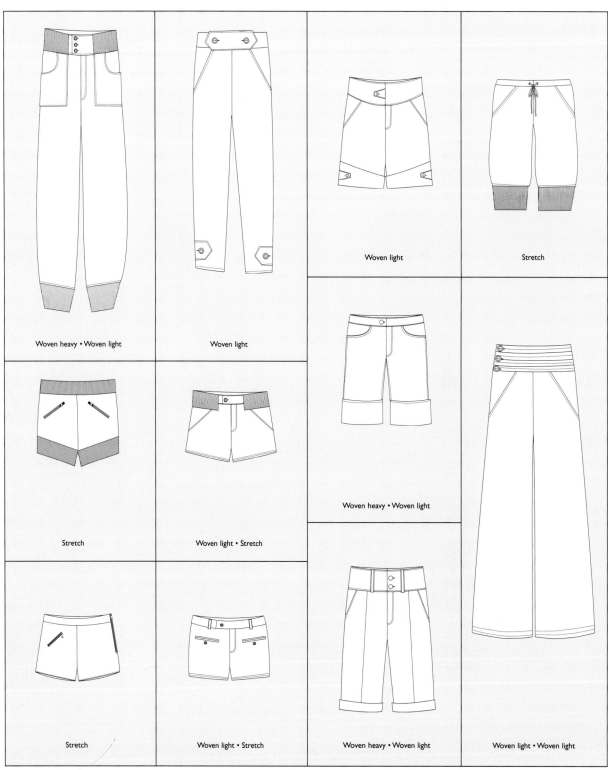

Woven heavy • Woven light

Woven light

Woven light

Stretch

Stretch

Woven light • Stretch

Woven heavy • Woven light

Stretch

Woven light • Stretch

Woven heavy • Woven light

Woven light • Woven light

Garment details are often subject to trends and historical reference, so be aware of contemporary styles to help you decide the look of your waistbands. Choose whether your waistbands go unnoticed or become focal points on your lower body garments.

1. Front tab
Tailored slouch trousers in linen with a belted waistband.

2. Front tab
Smart high-waist trousers with a front-tab waistband.

3. Front tab
Dropped-waist three-quarter-length trousers with a two-button front-tab waistband.

4. Belted
A simple belted waistband on uncomplicated trousers.

5. Paper bag
An exaggerated paper bag waistband gathered into the waist by a three-buckled belt gives a main focal point to the outfit.

6. Tab waistband
A dropped-waist tab waistband on a pair of boyish shorts.

7. Low waist
A low-waist zipped front waistband.

8. Front tab
Tailored trousers with a low-waist buttoned front-tab waistband.

SHORT AND TROUSER • WAISTBANDS (CONTINUED)

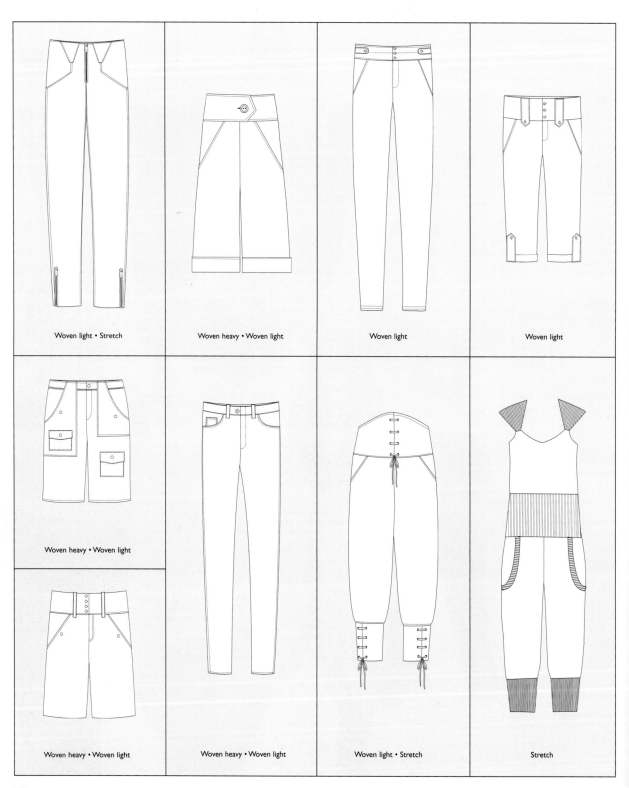

Woven light • Stretch

Woven heavy • Woven light

Woven light

Woven light

Woven heavy • Woven light

Woven heavy • Woven light

Woven heavy • Woven light

Woven light • Stretch

Stretch

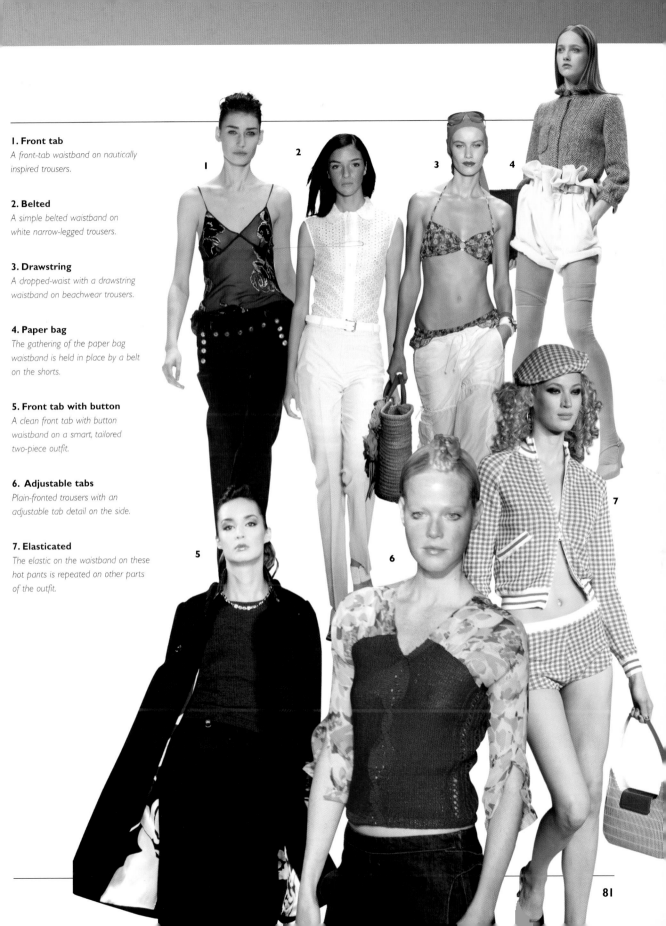

1. Front tab
A front-tab waistband on nautically inspired trousers.

2. Belted
A simple belted waistband on white narrow-legged trousers.

3. Drawstring
A dropped-waist with a drawstring waistband on beachwear trousers.

4. Paper bag
The gathering of the paper bag waistband is held in place by a belt on the shorts.

5. Front tab with button
A clean front tab with button waistband on a smart, tailored two-piece outfit.

6. Adjustable tabs
Plain-fronted trousers with an adjustable tab detail on the side.

7. Elasticated
The elastic on the waistband on these hot pants is repeated on other parts of the outfit.

SKIRT • WAISTBANDS

Waistbands should always flatter garments. Use them to provide some design interest and impact.

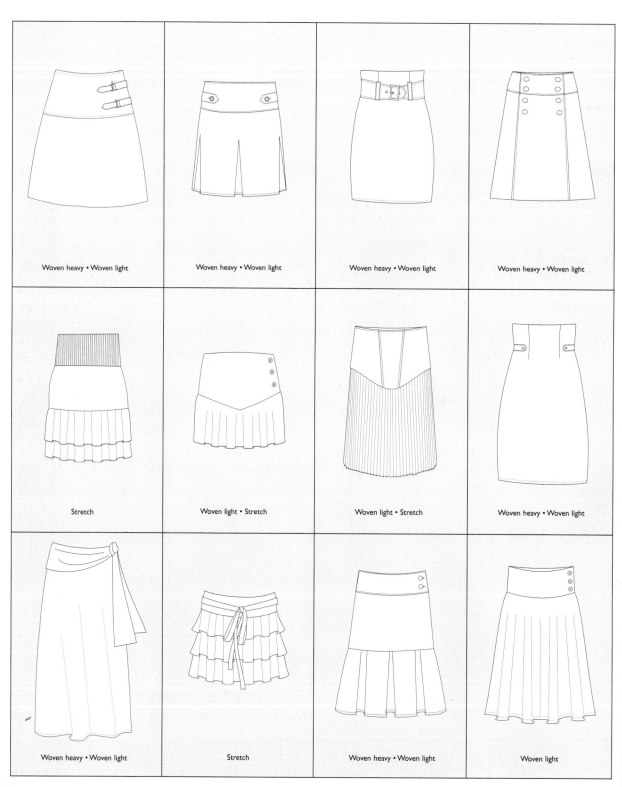

Woven heavy • Woven light	Woven heavy • Woven light	Woven heavy • Woven light	Woven heavy • Woven light
Stretch	Woven light • Stretch	Woven light • Stretch	Woven heavy • Woven light
Woven heavy • Woven light	Stretch	Woven heavy • Woven light	Woven light

Skirt waistbands can often go unnoticed if all they do is perform their function. Design interest in the waistband area of your garment can be varied and appealing. Comfortable functions married with style and interest can be achieved for your garment waistbands.

1. Faced
A faced waistband with suspenders gives this outfit a masculine appeal.

2. Drawstring
A relaxed drawstring finishes the skirt on this comfortable outfit.

3. Faced
A simple faced finish is used for this print-focused skirt and jacket.

4. Tied
A tied waistband works well in this woven lightweight fabric, giving the skirt added flare.

5. Curved waist
A stretch fabric has been used for this faced, curved waistband with front seam details in contrasting piping.

6. Banded waist
A pleated skirt in jacquard is completed with a neat banded waist.

7. Banded waist
A gathered skirt is finished with a simple banded waistband.

8. Elasticated
A wide elasticated waist area with fringing detail adds interest and focus.

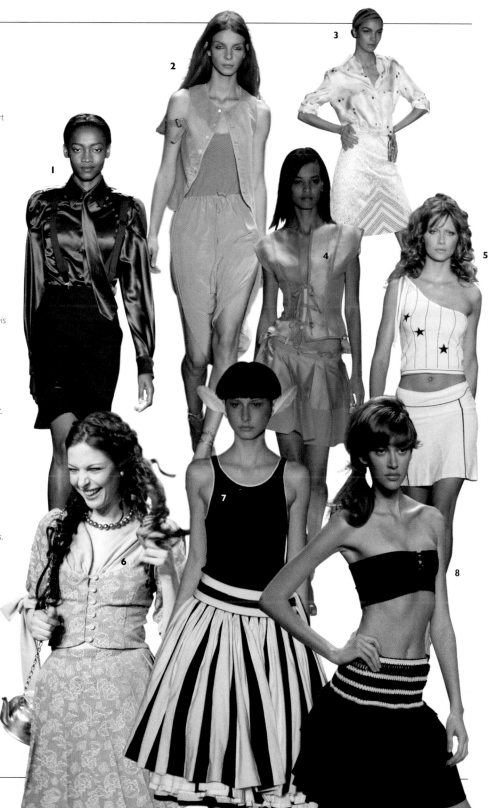

POCKETS

A fundamental detail on most garments, especially outerwear items such as coats and jackets. Most pockets primarily serve a utilitarian function. Modern living comes full of accessories – mobile phones, keys, credit cards, loose change – that we carry around with us in pockets that also provide refuge for our hands. If you anticipate much usage for your pockets, they will require reinforcements or even interfacing to strengthen the surrounding fabric. The various styles mean that you should also consider their location and the desired look.

JET

A smart finish with good stability, the jet pocket is often seen on tailored garments such as jackets, and the back pocket of trousers and skirts.

JET/BUTTON

The jet with button is mostly used for the rear pocket on tailored trousers.

JET/TAB

The jet with tab offers additional security for the pocket.

JET/FLAP

The jet with flap is more suited to fabrics with good stability.

JET/ REINFORCEMENT

Good for the front pockets on jackets and coats, the reinforced triangle ends of the jet provide strength and aim to lessen general pocket wear and tear.

CURVED JET

Another popular pocket for jackets and coats, the curved welt can also be used for skirts and trousers

SLANT

Commonly seen on trousers made from all types of fabrics, from gabardine to jersey.

CURVED

Similar to the slant, the curved pocket is just as popular and versatile.

CURVED AND TICKET

The curved and ticket pocket is widely used on jeans.

KANGAROO

Popular on the front of casual garments like sweatshirt tops made from stretch jersey.

BELLOWS

This capacious gusseted pocket is a useful detail on coats, jackets, trousers and skirts.

CARGO

Derived from military wear, the cargo pocket is commonly seen on trousers and skirts.

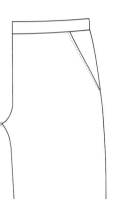
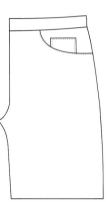

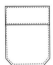
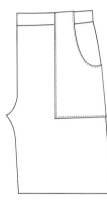

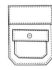
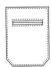
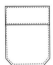

JET WITH ZIP

The zipped jet provides extra pocket security and is a very useful choice for the main pockets on jackets and coats.

PATCH DOUBLE

A practical and useful pocket with one pocket layered directly on top of another.

PATCH/WELT

This double pocket detail might be used for shirts and the inside pocket of tailored jackets.

PATCH

Versatile in its many uses, the patch pocket is seen in many guises and can be used for an array of garments including dresses, jackets, trousers and shirts.

PATCH WITH FLAP

The patch pocket with a flap provides a tidy finish to the design detail of any garment.

COAT AND JACKET • POCKETS

Coat and jacket pockets are essential outerwear details that need consideration. Think about the function, style, security and placement of the pocket.

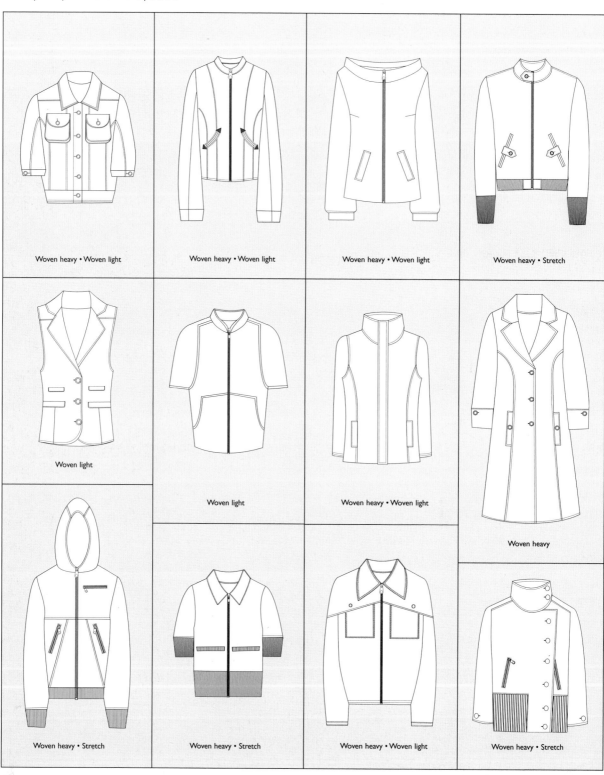

Woven heavy • Woven light

Woven heavy • Woven light

Woven heavy • Woven light

Woven heavy • Stretch

Woven light

Woven light

Woven heavy • Woven light

Woven heavy

Woven heavy • Stretch

Woven heavy • Stretch

Woven heavy • Woven light

Woven heavy • Stretch

Coat and jacket pockets need to be functional and hard-wearing, as they are likely to be in constant use. Balance the overall detailing on outerwear garments with the pockets, and seek a harmonious balance between all that is going on.

1. Welt
Welt pockets give this jacket a very wearable and casual look.

2. Side-seam pocket
An almost invisible pocket emerges from the side seam of the coat.

3. Reinforced topstitched zip pocket
A zip pocket and contrasting topstitching that highlights and becomes a feature.

4. Angle welt pocket
A tweed tailored jacket with an angled welt pocket.

5. Bellows pocket
A bellows pocket looks deceptively flat but the gusset provides room for personal items to be stored.

6. Zip pocket
A brightly contrasting functional zip on a sporty jacket.

7. Bellows pocket
Bellows pockets provide function and interest to this two-piece bold patterned outfit.

8. Side-seam pocket
The simplicity of the jacket is reflected in the invisible side-seam pocket.

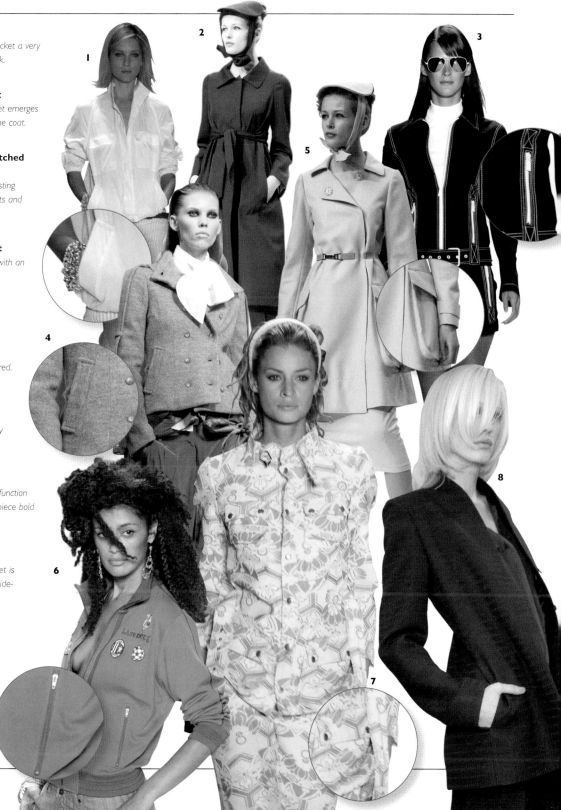

SHIRT AND BLOUSE • POCKETS

Give careful consideration to the design for shirt and blouse pockets. Remember that some pockets may be used for decorative as opposed to functional purposes.

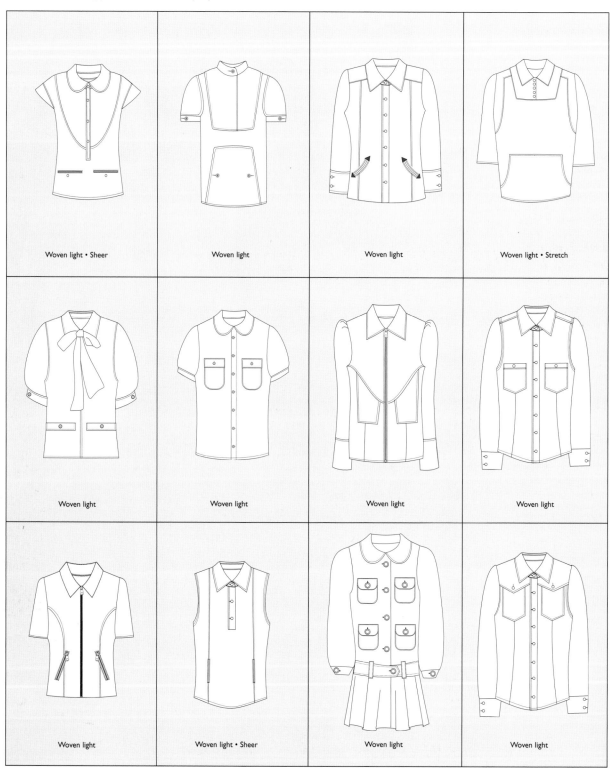

Woven light • Sheer	Woven light	Woven light	Woven light • Stretch
Woven light	Woven light	Woven light	Woven light
Woven light	Woven light • Sheer	Woven light	Woven light

Shirt and blouse pockets can vary in size, style and placement. Their functional use is limited to light or small items, as anything too big or heavy will cause the garment to drag downwards.

1. Patch with flap
A wide patch pocket with a flap.

2. Zip pocket
A fitted tunic with a theme of zipped pockets and metal fastenings.

3. Flap pocket
A flap pocket is used on this wide-shouldered military-inspired shirt.

4. Patch with flap
A fitted shirt with two gusseted patch pockets with flap.

5. Flap pocket
A flap pocket finished with a stud for the fastening.

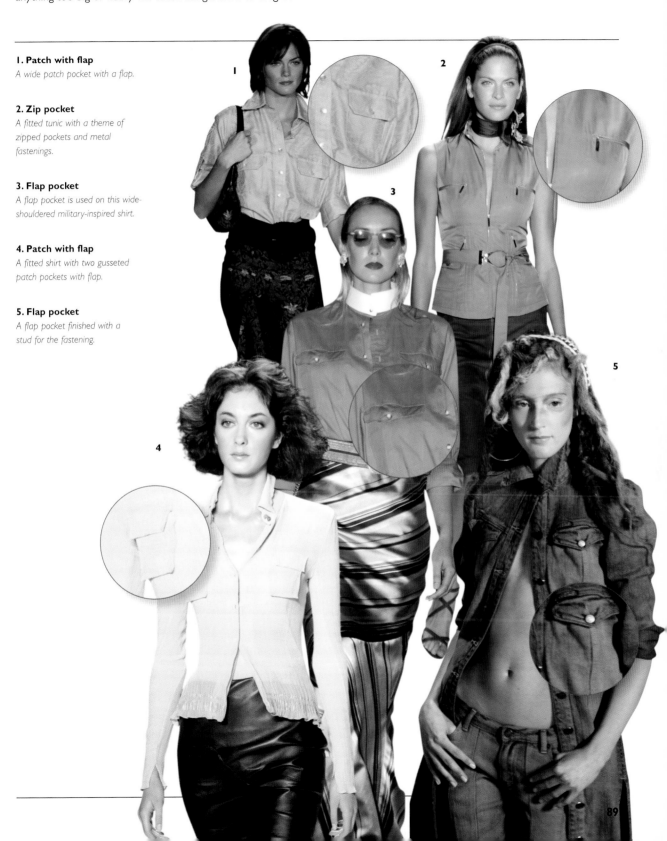

SHORT AND TROUSER • POCKETS

Most short and trouser pockets will be used to carry items or as a place for the hands, so they need to be functional. Pockets that are used frequently may need to be reinforced to limit wear and tear.

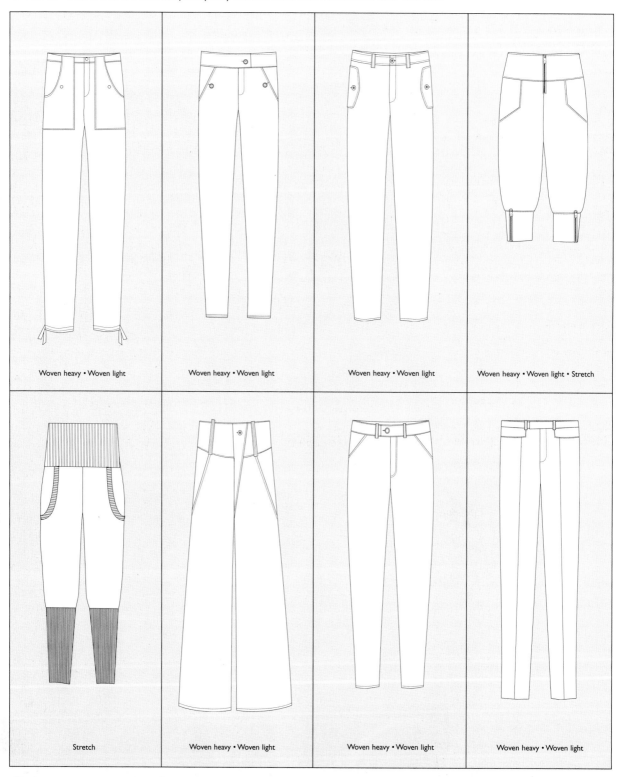

Woven heavy • Woven light	Woven heavy • Woven light	Woven heavy • Woven light	Woven heavy • Woven light • Stretch
Stretch	Woven heavy • Woven light	Woven heavy • Woven light	Woven heavy • Woven light

Consider the details on other garments in your capsule collection and whether they will influence your choices here, as you may choose to work to a theme of pockets throughout the collection. Keep the main pockets on your shorts and trousers functional and practical, as you should anticipate full use.

1. Cargo pocket
Slanted cargo pockets with a zip that provides additional safety for personal items.

2. Bellows pocket
Capacious bellows pockets have been used for the outer leg pocket on these glamorous combat trousers.

3. Curved
Curved pockets with a contrasting coloured binding edge are repeated on the upper body tunic.

4. Slant
Slanted pockets are given a decorative buttoned flap.

5. Patch with flap
These military-inspired trousers have patch pockets with a flap.

6. Rounded-flap pocket
A rounded flap with button completes these chequered pockets.

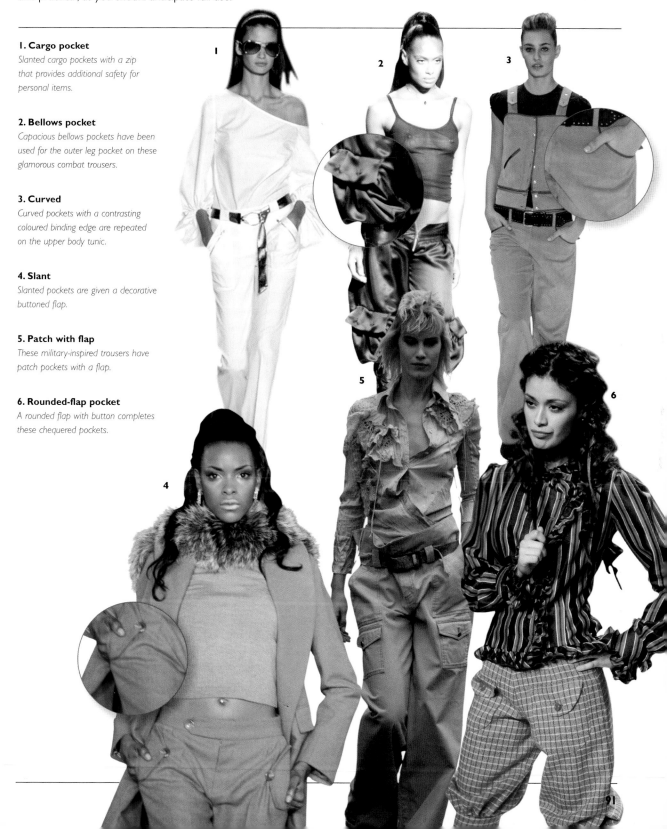

SKIRT • POCKETS

Whether your skirt pockets go unnoticed or form a main feature, there are plenty of style choices. Keep the main skirt hip pockets functional, and perhaps consider additional pockets for adornment purposes.

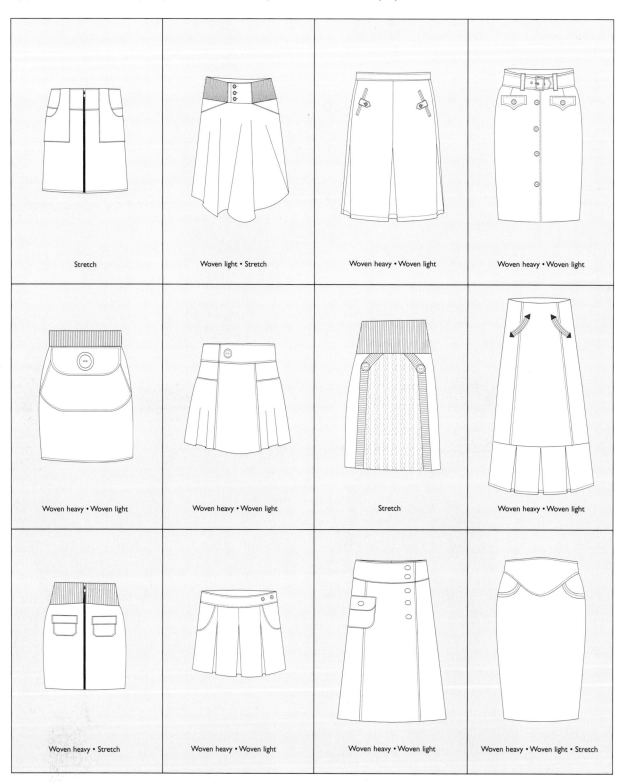

Stretch	Woven light • Stretch	Woven heavy • Woven light	Woven heavy • Woven light
Woven heavy • Woven light	Woven heavy • Woven light	Stretch	Woven heavy • Woven light
Woven heavy • Stretch	Woven heavy • Woven light	Woven heavy • Woven light	Woven heavy • Woven light • Stretch

Think about the current theme of pockets in your capsule collection and ensure that your skirt pockets reflect this. Integral garment details are sometimes used and repeated throughout capsule collections, acting as an anchor to hold the collection together.

1. Bellows pocket
This satin skirt has side bellows pockets and a square flap.

2. Zipped pocket
A knee-length skirt with stud front opening features vertical zipped pockets.

3. Patch pocket
This 1980s-inspired outfit has a denim mini-skirt with two front patch pockets.

4. Side-seam pocket
Side-seam pockets are concealed on this floral wide-pleated skirt.

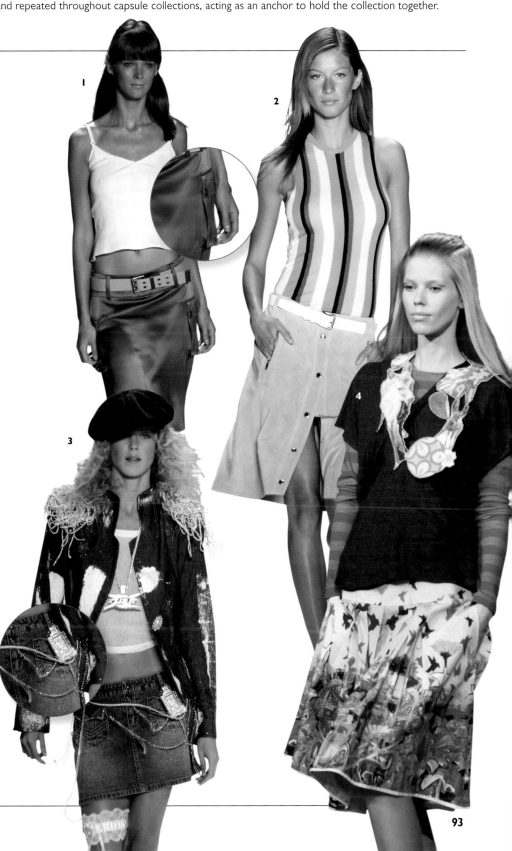

CUFFS

Whatever style you go for, the cuff region needs to accessorize and complement the rest of your garment's design as well as slip on and off easily. There are many ways in which you can incorporate ideas from your research into the cuffs of your garments, thereby bringing individuality to this integral area. There are so many styles to perk up your creations, from double cuffs, which will give a more formal look to your sleeve, to ribbed styles that tone down a garment for a more casual look.

Well-designed cuffs allow the arm and hand to pass through with ease, so remember to consider the type of opening and plan how it will work with the rest of the cuff design and sleeve you have in mind.

BELTED
The belted cuff can be seen as a signature detail on outerwear garments. Its style originates from the traditional raincoat and provides a formal, controlled finish. The belt function is used to tighten the wrist area of a garment.

BOUND
This comfortable, casual-effect cuff has a permanent opening finished with a neat edge.

BUTTON TAB
Often seen on coats or jackets, the button tab fastening gives a formal look to the cuff area.

KEYHOLE
A small opening closed off at the base of the sleeve by a rouleau-loop and button fastening. This type of cuff may work well for sheer or woven medium-weight fabrics.

ELASTICATED
Finished with a piece of elastic sandwiched into the cuff's hem area, this adjustable option sits snugly on the wrist.

FRILLED
This dressy option adds class to fabrics that already have some drape. The frill provides a gentle, feminine finish that sits on top of the hand.

DOUBLE

A formal cuff with a placket and two buttons as a closing, the double cuff is a popular detail for shirts and lightweight jackets.

SINGLE

Very popular on shirts, single cuffs usually have a small vent opening at the back that allows the hand to slide through. They generally fasten with a button.

PLACKET

This cuff provides a simple opening for the hand to pass through.

LACED

Reminiscent of the laced-up corset, it does the same job. Consider using a contrasting lace to perk up the cuff region.

FACED HEM

Minimalist in appearance and easy to design, this simple finish works well with most types of fabrics.

TRAM-LINED

This type of hem finishes the cuff region with parallel topstitching that encircles the whole of the cuff for a finish that is smart and minimal.

RIBBED

Often seen on casualwear garments or sportswear, the ribbed area stretches when the hand passes through and goes back into shape to sit on the wrist.

FITTED

This fitted cuff with gathered sleeve works well in most medium and sheer weight fabrics.

TURN-UP

Twice the length of a normal cuff, the extra fabric is used as a turnback. Turn-up cuffs are seen on formal shirts and can be closed off with cuff links or a button.

VENTED

This detail originates from the back of coats. When seen on cuffs it provides a smart and functional finish.

ZIPPED

The zipped cuff gives easy access and provides a tailored fit to the wrist area.

COAT AND JACKET • CUFFS

Cuffs can be decorative as well as functional. Revisit your moodboard and be guided by your research and inspiration as to how you design the cuff area.

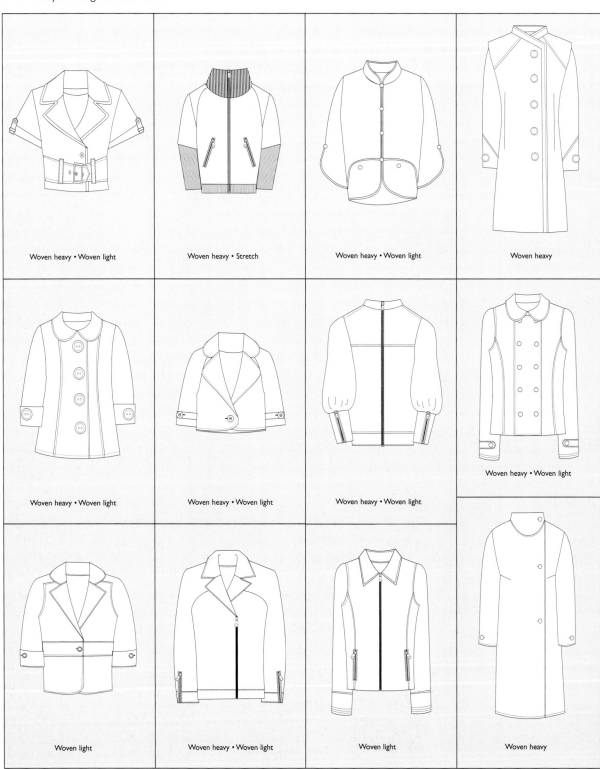

Woven heavy • Woven light

Woven heavy • Stretch

Woven heavy • Woven light

Woven heavy

Woven heavy • Woven light

Woven heavy • Woven light

Woven heavy • Woven light

Woven heavy • Woven light

Woven light

Woven heavy • Woven light

Woven light

Woven heavy

Outerwear cuffs need to reflect and complement, not overpower, the other details on the garment. They should be practical, and easy for the hand to pass through.

1. Vented cuff
A sharp jacket and trousers two-piece has an appropriately tailored vented cuff that completes the look.

2. Faced hem cuff
A simple finish to the cuff area completes the sleeve on this printed coat.

3. Button tab
A military-inspired jacket has a smart button-tab finish to the cuff area.

4. Elasticated
A practical elasticated cuff is used on this raincoat.

5. Oversized cuff
This simple cuff has a fresh appeal when seen in a faux-fur fabric.

6. Elasticated
A clean elasticated cuff finishes this sporty outfit.

7. Elasticated
Decorative detail to the cuff area adds interest.

1

2

3

4

5

6

7

SHIRT AND BLOUSE • CUFFS

As with all of your garment details, your cuffs will complement your overall designs and this simple detail should not be overlooked.

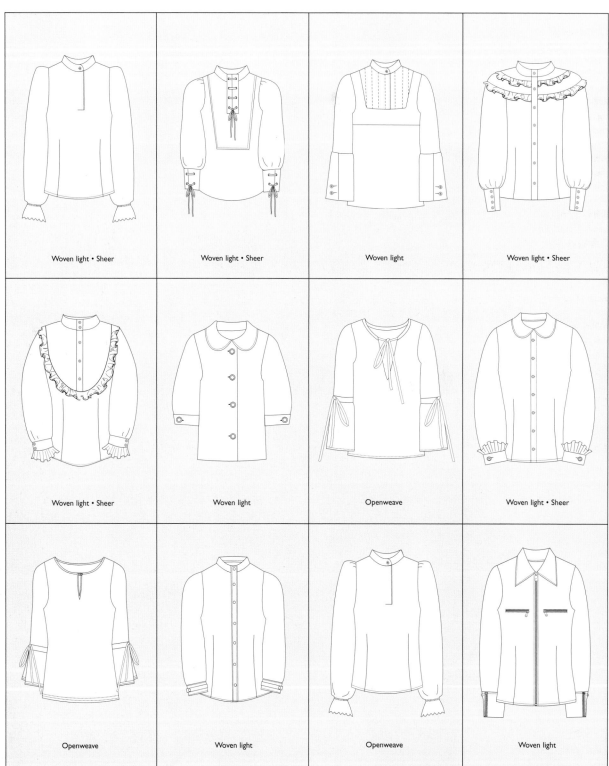

Woven light • Sheer	Woven light • Sheer	Woven light	Woven light • Sheer
Woven light • Sheer	Woven light	Openweave	Woven light • Sheer
Openweave	Woven light	Openweave	Woven light

The practical purpose of a cuff is to prevent the sleeve material fraying, but this practicality need not invalidate style. Cuffs need to be designed with fashion as well as function in mind.

1. Frill cuff
Design details from the front of the shirt have been carried through to the cuff area.

2. Turn-up
The turn-up cuff on this shirt has a relaxed, chic feel.

3. Shirt cuff
This simple shirt has a two-buttoned shirt cuff.

4. Bound cuff
A neatly bound cuff is used on this chiffon shirt.

5. Fitted cuff
A sleek fitted cuff fits the overall design of this outfit.

6. Frill cuff
Design details from the front of the shirt have been carried through to the cuff area.

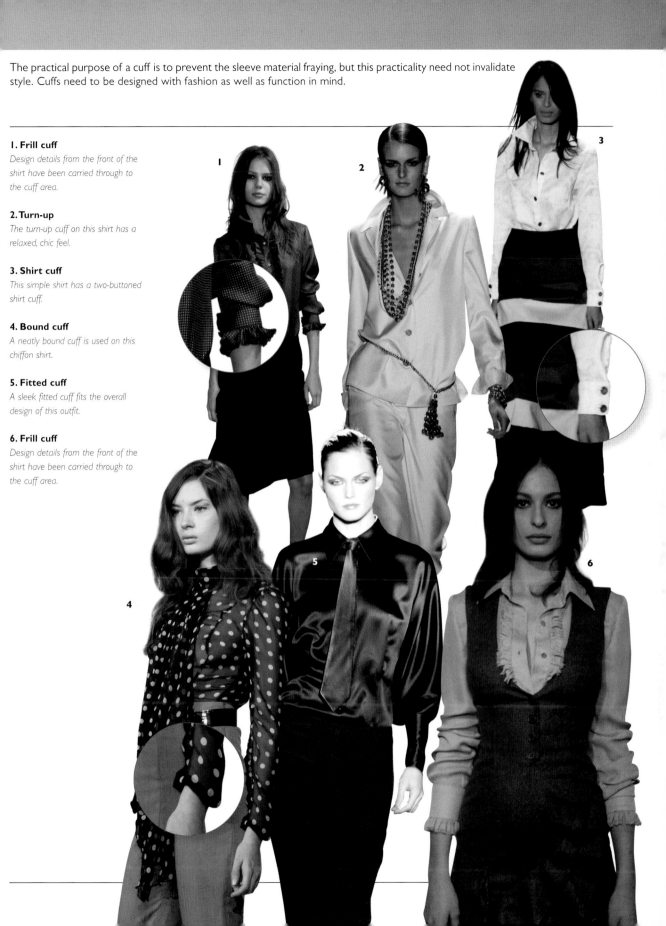

TOP • CUFFS

Be creative and inventive for your tops' cuffs. Remember ideas from your theme or inspiration to help guide your thoughts.

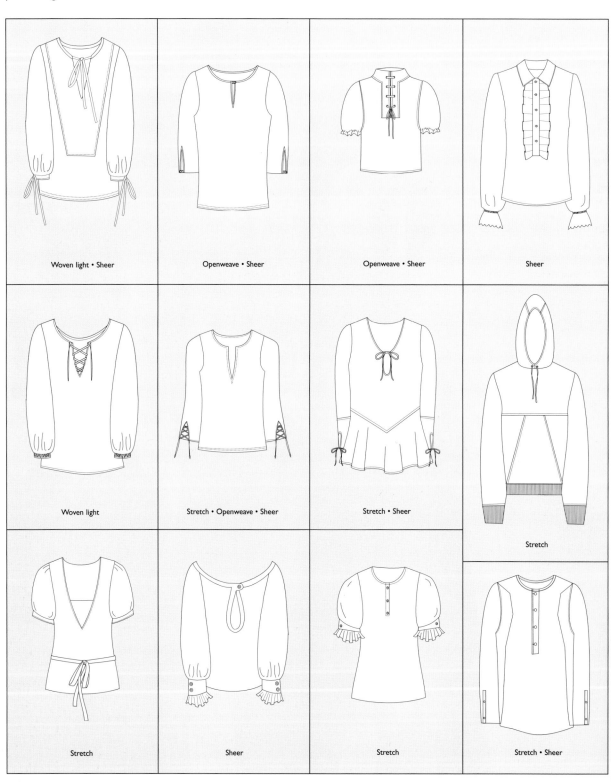

Woven light • Sheer

Openweave • Sheer

Openweave • Sheer

Sheer

Woven light

Stretch • Openweave • Sheer

Stretch • Sheer

Stretch

Stretch

Sheer

Stretch

Stretch • Sheer

Cuffs for tops are wide-ranging and varied. Consider your fabric's strengths and limitations and use this to help create a cuff suitable for your designs. A correct balance of detail is what will make your garment successful and desirable.

1. Shirt cuff

This eveningwear outfit has a shortened sleeve with a shirt cuff.

2. Frill cuff

A top in lightweight woven chiffon with a drawstring neckline, and a frill cuff.

3. Faced hem

A faced-hem cuff in satin fabric repeats a detail that is also seen on the neckline.

4. Keyhole opening with ties

A wide sleeve with a keyhole opening and ties combines form and function.

5. Shirt cuff

A shirt cuff in a contrasting colour adds interest to this modest shirt.

6. Fitted cuff

A gathered sleeve with a fitted cuff completes this period-inspired outfit.

7. Vented cuff with ruching

The vented cuff and ruching on this top are reflected in other parts of the garment.

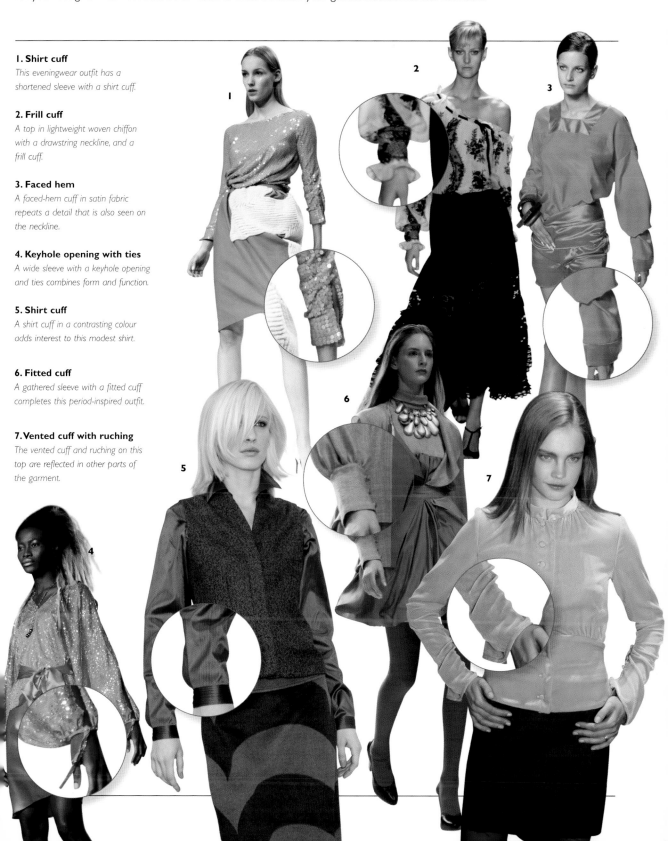

KNITWEAR • CUFFS

The elastic nature of yarn makes it ideal for creating snug fitting cuffs that cling to the wrist or arm. Looser cuffs are achievable too, depending on the stitch chosen.

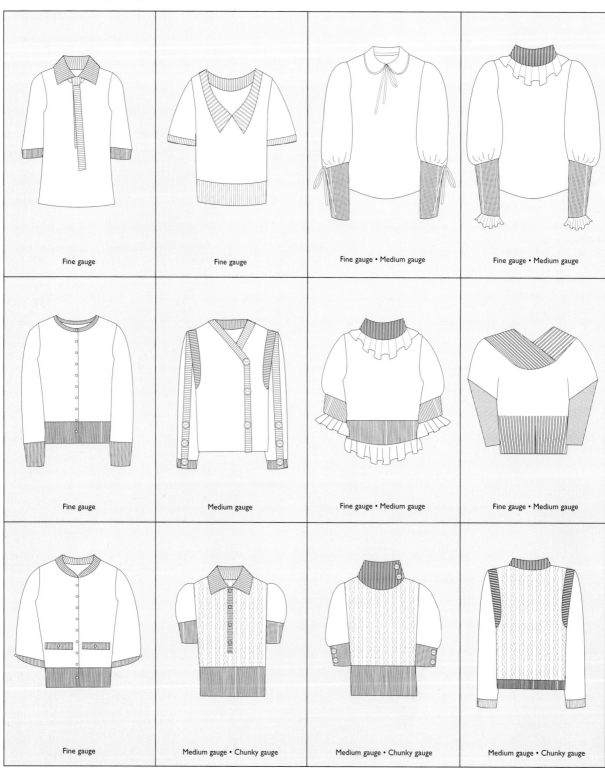

Fine gauge

Fine gauge

Fine gauge • Medium gauge

Fine gauge • Medium gauge

Fine gauge

Medium gauge

Fine gauge • Medium gauge

Fine gauge • Medium gauge

Fine gauge

Medium gauge • Chunky gauge

Medium gauge • Chunky gauge

Medium gauge • Chunky gauge

Varying lengths, rib widths and thickness of yarn will affect the look and finish of your knitwear cuffs. Be creative with your knitwear cuffs and consider how they will work with the rest of your capsule collection.

1. Gathered cuff
This multicoloured knit has a cuff with a puckered effect, giving focus to that area of the garment.

2. Fitted cuff
An elongated fitted cuff in contrasting coloured knit balances the overall design of this sleek dress.

3. Ribbed cuff
The emphasis is on the neckline of this chunky knitted dress; the cuff is kept uncomplicated.

4. Ribbed cuff
Three-quarter-length sleeves are finished with a ribbed cuff.

5. Turn-up cuff
A knitted turn-up cuff completes this simple sweater.

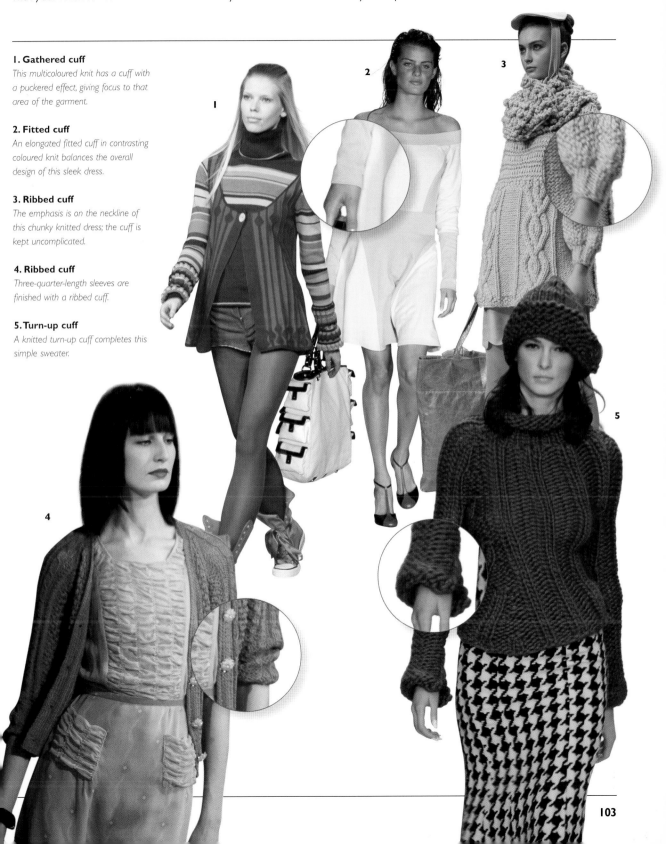

FASTENINGS

Fastenings are essential in garment designs. They can provide essential function and sometimes decoration to clothing. There are many varieties of fastenings, and knowing which one is the best to choose for the job can be confusing. Shown here are the most commonly used fastenings.

BUTTON TAB

The button tab is versatile and can be used in both a decorative and functional capacity.

D-RINGS

D-ring fastenings make an interesting alternative to a buckle.

FROG

This decorative fastening can be used as a feature opening for coats and jackets.

HOOK AND EYE

A discreet fastening that is usually kept hidden. A hook and eye will support the top end of zips, or can be used in its own right in a continuous row.

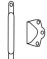

HOOK AND BAR

The hook and bar is commonly used on the inside waistband of trousers.

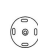

POPPERS

Versatile and practical, these provide a clean and discreet fastening for coats, jackets and other garments.

BRACES

Historically used for menswear, but in recent years braces have been in and out of womenswear fashion.

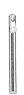

BOW

A tied bow will finish your garment as well as provide a functional fastening.

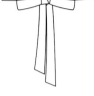

BUCKLE

The classic buckle is a practical design, and is widely used on belts.

DRAWSTRING

The drawstring is a relaxed fastening, useful for the waist, hems, cuffs and necklines.

TASSEL

The tassel is a decorative finish that you could apply to the end of a drawstring.

LACE-UP

This versatile, practical and decorative fastening can be used for necklines, cuffs, waists and hems.

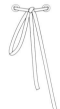

CLOSED-ENDED ZIP

The closed-ended zip can be used as an opening for pockets or as an insert on cuffs and for front fly openings.

TWO-WAY ZIP

Since it opens from the top or bottom, this zip is useful for front openings on coats and jackets, as well as being great for bags.

SEPARATING ZIP

When unzipped this style allows the garment to open completely. They are most commonly used on coats or jackets.

ROULEAU LOOPS

Rouleau loops are a delicate fastening, good for neckline openings, side seam openings or cuff openings.

BUTTONS

Widely used for front fastenings, fly fastenings, tabs and cuffs. Buttons are exceptionally useful on many parts of a garment.

TOGGLE

Toggles can be used as a feature fastening for the front of coats and jackets.

COAT AND JACKET • FASTENINGS

Function and ease should be your priority when designing fastenings for outerwear. The type of fabric you are using may dictate the most suitable fastening – let your research guide your ideas but be aware of practical considerations.

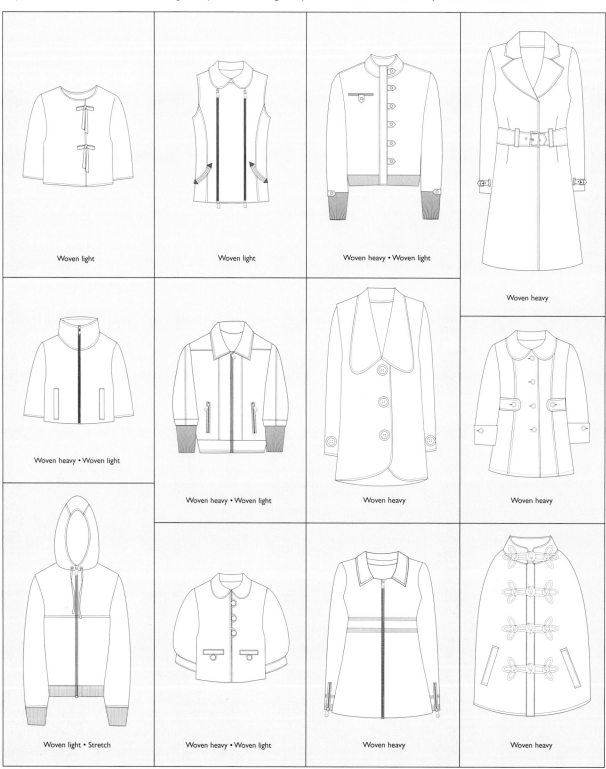

Woven light

Woven light

Woven heavy • Woven light

Woven heavy

Woven heavy • Woven light

Woven heavy • Woven light

Woven heavy

Woven heavy

Woven light • Stretch

Woven heavy • Woven light

Woven heavy

Woven heavy

Coat and jacket garment fastenings can be varied and interesting, and in some cases may become the main feature on your garment. Think about the type of fastenings you have already used and how those used on your coats and jackets will fit into the theme of what already exists in your collection.

1. Button

A crossover button detail becomes a prominent feature on this jacket.

2. Button

A simple row of buttons is used to ensure a minimal effect on this lean coat.

3. Bow

A long rope tied into a bow becomes the fastening on this beautiful period-inspired coat.

4. Belt

The belt on this wide coat creates a nipped-in gathered waist.

5. Popper

This caped coat has a plain front with a daring popper fastening at the neckline, which allows the coat to flow when the wearer moves.

6. Frog

The frog fastening on this Mandarin-style jacket becomes a main feature.

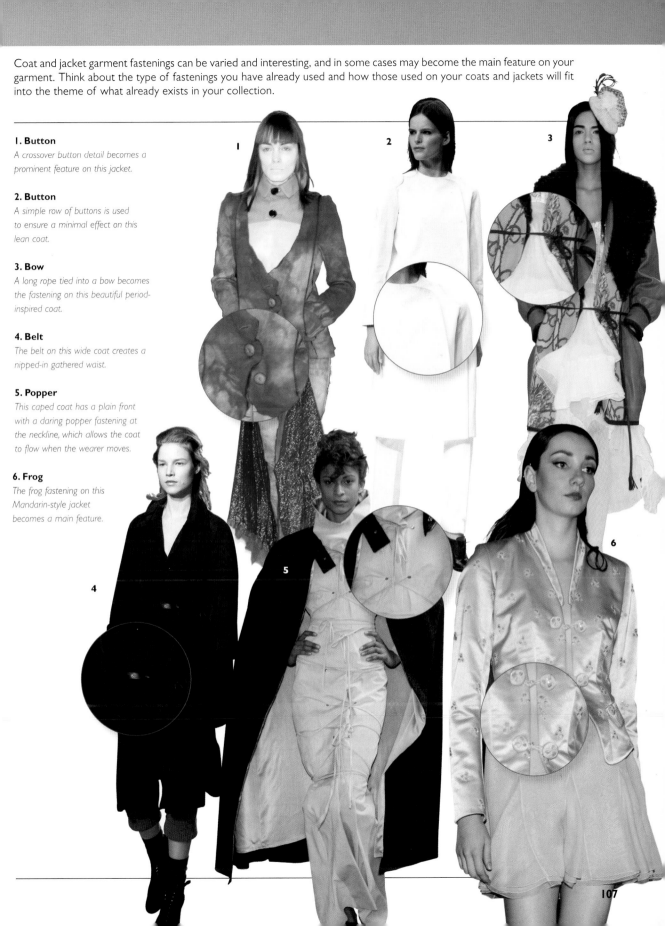

SHIRT AND BLOUSE • FASTENINGS

Try to use your fabric to its best effect by choosing the most suitable fastening for your design as well as thinking about its functions and practicality. In some cases the fastening may become a design feature in its own right.

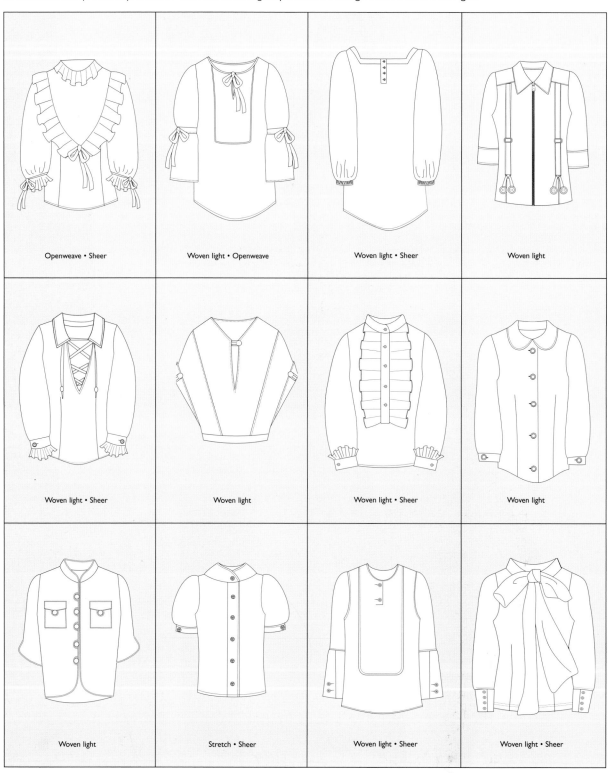

Openweave • Sheer

Woven light • Openweave

Woven light • Sheer

Woven light

Woven light • Sheer

Woven light

Woven light • Sheer

Woven light

Woven light

Stretch • Sheer

Woven light • Sheer

Woven light • Sheer

Shirt and blouse fastenings can be bold, practical and in some cases, sexy. Keep your design in tune with the rest of the collection and also imagine your garment being worn over a good-fitting, simple pair of denim jeans.

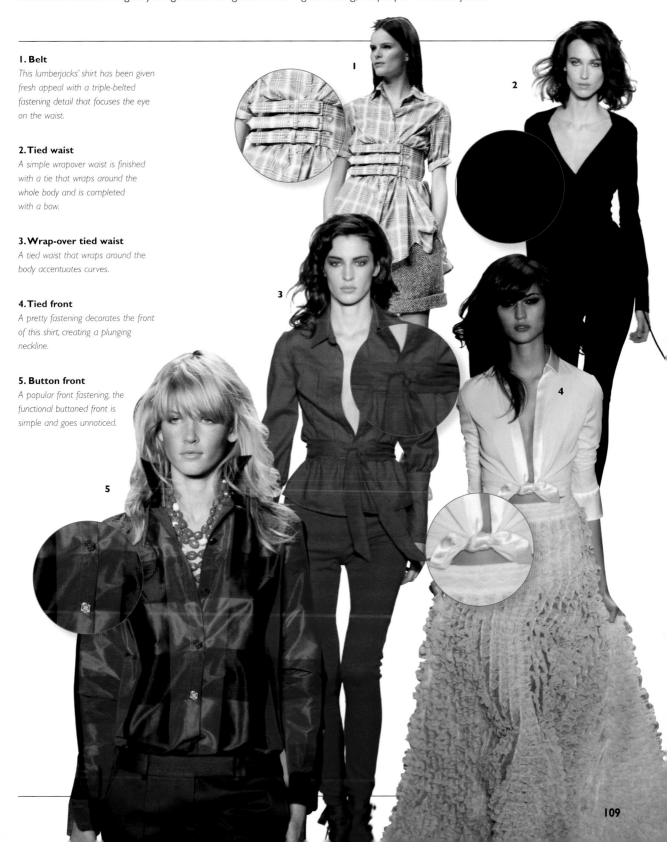

1. Belt
This lumberjacks' shirt has been given fresh appeal with a triple-belted fastening detail that focuses the eye on the waist.

2. Tied waist
A simple wrapover waist is finished with a tie that wraps around the whole body and is completed with a bow.

3. Wrap-over tied waist
A tied waist that wraps around the body accentuates curves.

4. Tied front
A pretty fastening decorates the front of this shirt, creating a plunging neckline.

5. Button front
A popular front fastening, the functional buttoned front is simple and goes unnoticed.

SHORT AND TROUSER • FASTENINGS

Short and trouser fastenings and openings have decorative and functional qualities. They can become a main feature or can fade into the background.

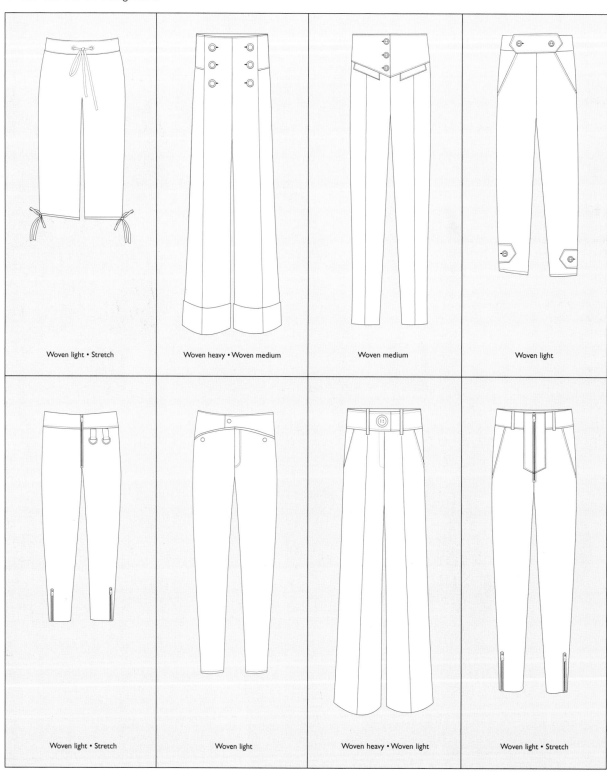

Woven light • Stretch

Woven heavy • Woven medium

Woven medium

Woven light

Woven light • Stretch

Woven light

Woven heavy • Woven light

Woven light • Stretch

Short and trouser fastenings should be functional and practical, and designed with your choice of fabric in mind. However, there is still scope to be imaginative and add interest to your fastenings if you want them to become a focal point of the outfit.

1. Belt
A smart belt made from the same fabric as the trousers gives a twist to this traditional fastening.

2. Belt
This stylish two-piece tailored outfit has a suitably smart belted fastening.

3. Lace
Daring leather shorts are given an equally daring lace-front fastening.

4. Zip
A pared down zip front completes these trousers and doesn't divert the eye from the graphic top.

5. Lace
The laced front on these denim shorts is finished with contrasting topstitching that highlights the detail.

6. Zip
Low-waist trousers that have a functional zip-front.

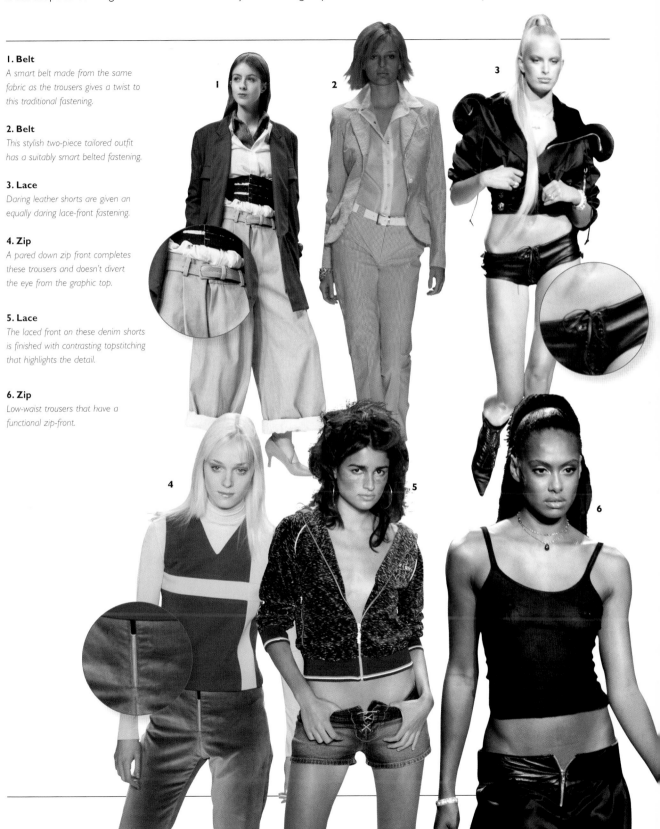

HEMS

Hems not only finish the lower edge of the garment, protecting it from unravelling, they also can be used as a fashion design element. The ways in which you can incorporate some kind of design feature into the hem of your garment are considerable.

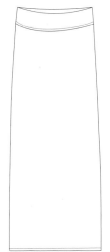

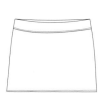

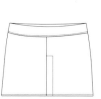

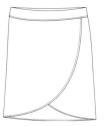

LONG

The longer length elongates the silhouette with the hem sitting near the ankle.

MID LENGTH

The mid-length hem sits just below or on top of the knee.

SHORT

The shorter length hem sits around the middle of the thigh.

SINGLE-VENTED

The single-vented hem can be used on any skirt length, as a front or back detail, and will provide extra room for movement.

WRAPOVER

The wrapover hem can also work with any length of skirt. Make a feature of the lining, as the wrapover tends to flap backwards.

LAYERED

The layered hem is ideal for contrasting or complementing colours.

ASYMMETRIC

The asymmetric hem is longer on one side and shorter on the other.

CURVED

The curved hem works best on short or mid-length skirts.

HANDKERCHIEF

The handkerchief detail can be used on the front or back of a skirt and will work on both short and mid lengths.

SCALLOPED

The scalloped hem has a wavy edge, which will need to be finished with a facing.

TURN-UP

The turn-up hem will suit any length. You may consider the width of the turn-up, and use a contrasting or complementary fabric for it.

ADJUSTABLE

The adjustable hem uses tabs to change the length and create a new look to the design.

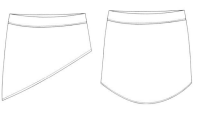 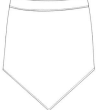

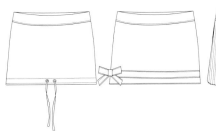

DRAWSTRING

The drawstring hem has a sporty feel and would work with both stretch and woven fabrics.

TOPSTITCH BINDING

This decorative hem is finished with bias binding and topstitching.

PLEAT

Popularized in the 1970s, the pleated hem is a classic and works well in most lengths of skirt.

INSERT FRILL

A decorative hem with a feminine appeal, will work on mini, mid- and calf-length skirts.

FRINGING

This decorative hem provides movement. The width of the fringing can be adjusted.

RIBBED

The ribbed hem pulls in at the bottom. The width of ribbing around the hem can be adjusted.

COAT AND JACKET • HEMS

Function and style must be paramount when designing wearable garments. The hem of your coat or jacket must be appropriately designed and in keeping with the style of the garment.

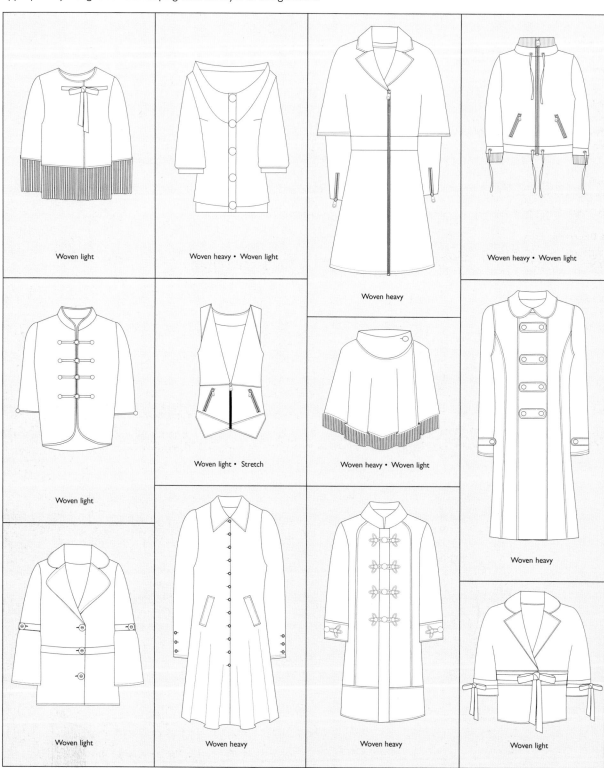

Woven light

Woven heavy • Woven light

Woven heavy

Woven heavy • Woven light

Woven light

Woven light • Stretch

Woven heavy • Woven light

Woven heavy

Woven light

Woven heavy

Woven heavy

Woven light

There is nothing wrong with keeping your hem simple or unnoticeable if that is your intention, but if you want to add interest then consider the vast hem possibilities that exist.

1. Insert frill hem
A lowered waist with a banded hem leads into an insert frill.

2. Turn-under hem
A popular finish for many hem areas, the turn-under hem is versatile and easy to achieve.

3. Banded hem
This multi-layered oversized denim-style jacket has a banded hem.

4. Drawstring hem
A drawstring hem plays up this jacket's casual elegance.

5. Asymmetric hem
This organic jacket has a flattering asymmetric hem.

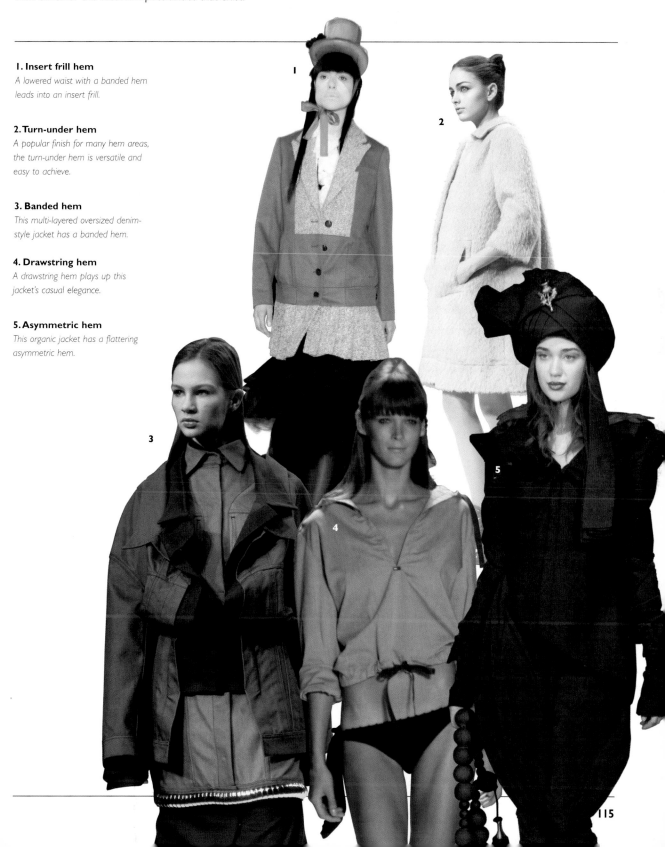

SHORT AND TROUSER • HEMS

Hems for shorts and trousers should be functional and stylish. Carry out some research and explore ideas to help you decide on the right one for your garment.

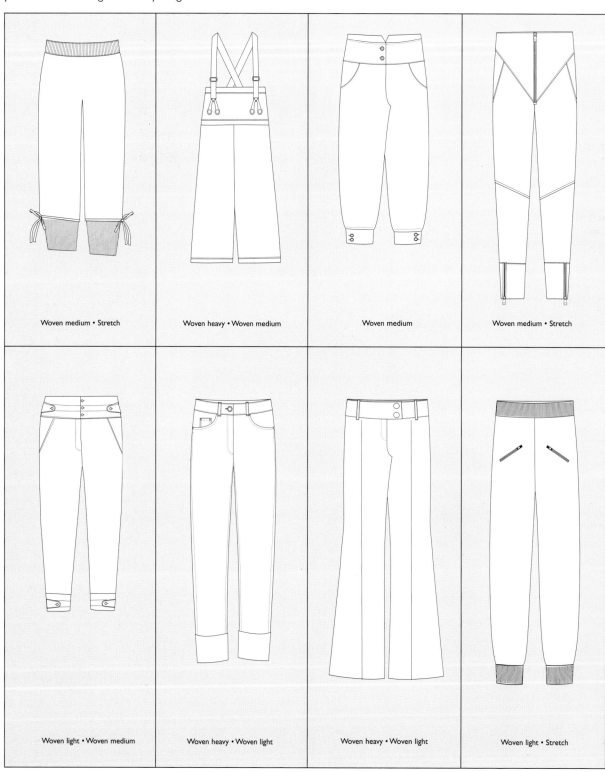

Woven medium • Stretch

Woven heavy • Woven medium

Woven medium

Woven medium • Stretch

Woven light • Woven medium

Woven heavy • Woven light

Woven heavy • Woven light

Woven light • Stretch

It's easy to make your hems a main feature on your garment. Balance design details with proportions and think about what is going on with the rest of the outfit. Marry your ideas together to create a harmonious, creative design.

1. Turn-under hem
Wide casual trousers in woven wool fabric call for a simple hem.

2. Cuffed hem
The cuff detail can be versatile on the hem area of calf-length trousers.

3. Ribbed hem
The ribbed hem is a feature detail that has been used on other parts of this outfit.

4. Turn-up hem
Originally a detail seen on men's tailored trousers, the turn-up hem gives a smart finish.

5. Insert frilled hem
The all-over use of the insert frill gives these trousers a playful look.

6. Front-slit hem
A daring front slit provides a revealing view of leg.

7. Flared hem
Flared trousers popular in the seventies, are often revived in short-lived fashion trends but the style has proved long lasting.

8. Turn-under hem
A deep turn-under hem with straight stitching almost becomes a feature in its own right.

SKIRT • HEMS

Skirt hems can be playful or serious. Think about your fabric and play on its strengths when you are considering your choice of hem, but keep it practical and wearable.

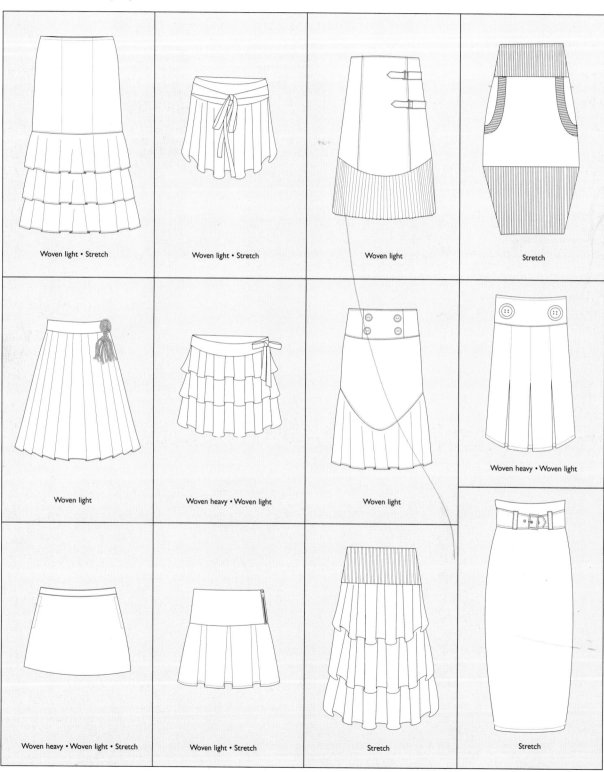

Woven light • Stretch	Woven light • Stretch	Woven light	Stretch
Woven light	Woven heavy • Woven light	Woven light	Woven heavy • Woven light
Woven heavy • Woven light • Stretch	Woven light • Stretch	Stretch	Stretch

Try to flatter the wearer's body with your choice of skirt hem. Whether your collection is sexy and flirty or simple and wearable, make your skirt hems distinctive.

1. Asymmetric insert frill hem
This skirt has a feminine feel with an asymmetric insert frill hem and a lace-up feature.

2. Banded hem
A banded hem completes this wearable skirt in a striking colour.

3. Layered hem
The long layers in tulle give this outfit a feminine yet hard-edged appeal.

4. Asymmetric hem
This floaty hem is achieved by working directly onto a body or dress stand and uses the fabric to its best effect.

5. Fringed hem
A fringed hem is mobile and reveals the legs when the wearer is walking. To achieve fringing, choose fabric that will not fray.

6. Turn-under hem
A casual loose skirt in jersey gets a turn-under finish for the hem.

7. Topstitch binding
A circle skirt with a layered underskirt uses bright topstitched binding for the hem.

DRESS • HEMS

Dress hems contribute significantly to the overall finish and look of the garment. Design with your research influences in mind, and let your fabric dictate the type of hem finish it requires.

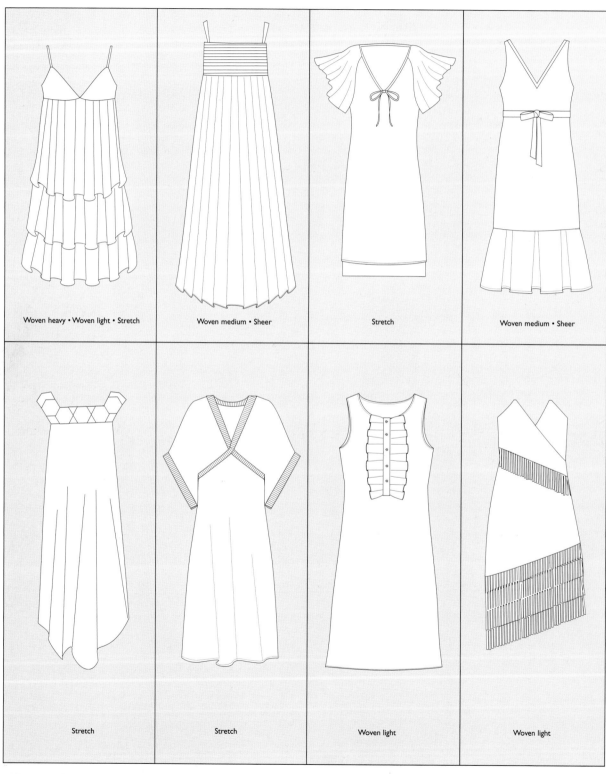

Woven heavy • Woven light • Stretch

Woven medium • Sheer

Stretch

Woven medium • Sheer

Stretch

Stretch

Woven light

Woven light

Consider whether your design is for daywear or eveningwear. The possibilities for dress hems are endless: modest, minimal, floaty or frilly, your dress hem definitely influences the "feel" of the outfit.

1. Insert frill
This light chiffon layered dress has a harmonizing insert frill hem.

2. Turn-under pin hem
The hem of this satin dress has been finished with a neat turn-under pin-tuck hem.

3. Side-slit hem
The hem of this side-slit transparent dress has been finished with a turn-under pin, which works well for the fabric.

4. Layered
A frilly, layered hem finishes this dress.

5. Asymmetric hem
A turn-under pintuck hem completes this asymmetric satin dress.

6. Insert frill
This short dress has a playful feel with added interest from the insert frill hem.

7. Asymmetric hem
This organic asymmetric hem has historical influences behind its creation.

8. Puffball hem
This hem is created by excess fabric gathered into a band, creating a puffball effect.

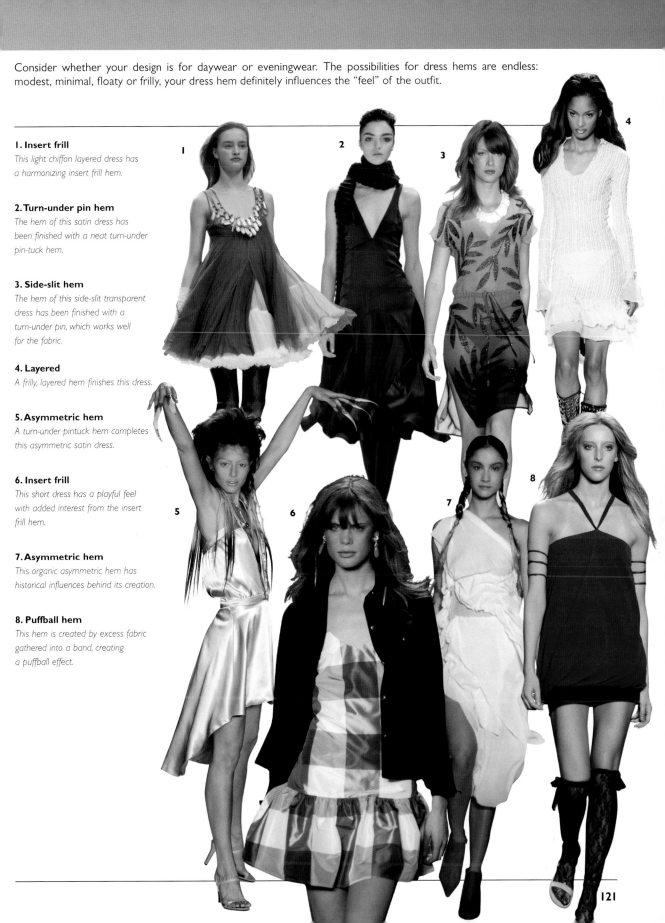

KNITWEAR • HEMS

Look to your inspiration for ideas and choose a yarn that can achieve the finish you require. Knitwear gives you the scope to be adventurous and creative, so apply this to your hems and find stylish and exciting design ideas.

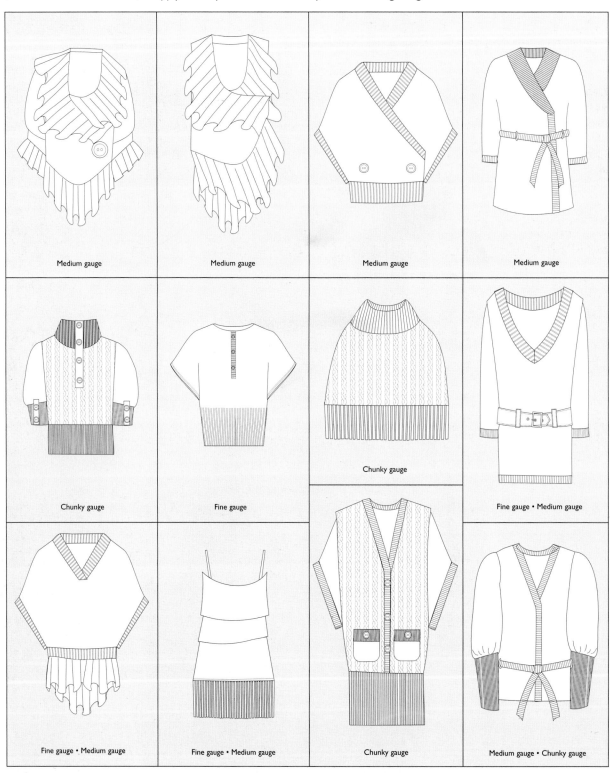

Medium gauge

Medium gauge

Medium gauge

Medium gauge

Chunky gauge

Fine gauge

Chunky gauge

Fine gauge • Medium gauge

Fine gauge • Medium gauge

Fine gauge • Medium gauge

Chunky gauge

Medium gauge • Chunky gauge

The look and feel of knitwear can be altered dramatically by the type of yarn you are using. Whether your garment has the look of handknitted and cozy, or slinky and sexy, use the hem finish to complement the overall design.

1. Ribbed hem
This oversized handknitted tunic has a small ribbed hem finish.

2. Ribbed hem
A precise ribbed finish is used on this belted sweater.

3. Ribbed hem
The ribbing on the hem of this cardigan creates a bag-like effect.

4. Scalloped hem
A slinky dress finished with a pretty scalloped hem.

5. Wide-ribbed hem
The wide ribbing detail on this sweater is also reflected on the neck and sleeves.

6. Ribbed hem
A ribbed hem is the finish for this knitted coat.

7. Curved-ribbed hem
This slouch knitted jacket has a curved hem.

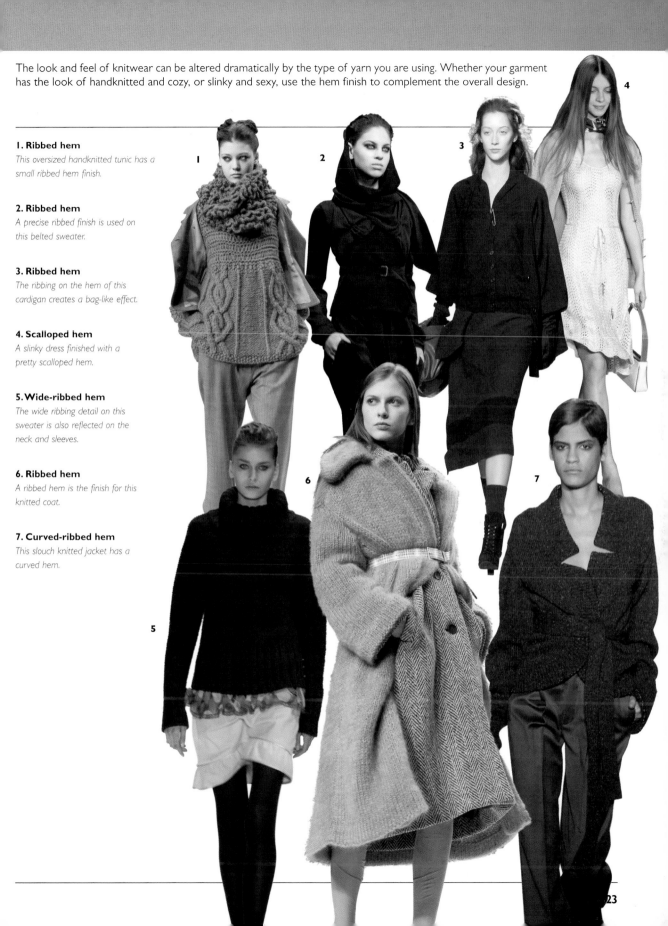

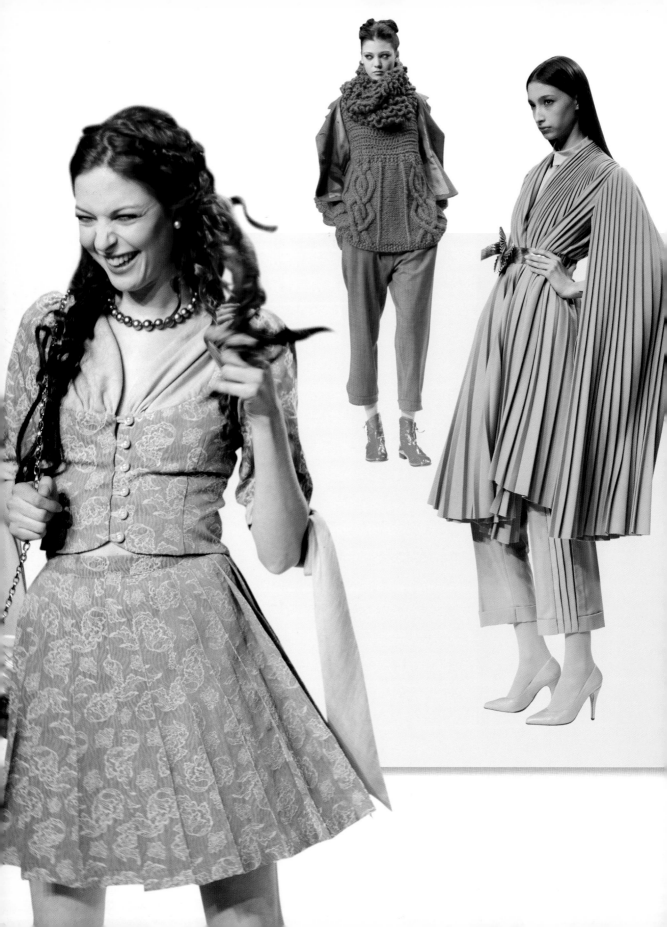

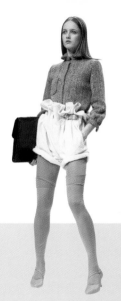

CHAPTER 3

THE TEXTILE DIRECTORY

The textile directory will help you identify fabrics. You will find a visual guide of swatches, as well as listings of the fabric's properties with helpful suggestions for possible applications. Refer to this directory when you begin to select your fabrics.

THE TEXTILE DIRECTORY

When designing your capsule collection, you need to consider fabrics with care. They are fundamental to any garment design and need to be fully examined for their weight and drape, as well as their tactile and visual qualities.

This textile directory is separated into five fabric categories – medium-weight woven, heavyweight woven, openweave, sheer and stretch. Each category goes on to name, describe and give the general properties of different kinds of fabrics and advises on the kinds of garments for which each would be most suitable. Familiarize yourself with the spectrum of fabrics that are out there before starting your selection.

'TIS THE SEASON

Critical for your fabric selection is the season for which you are designing your collection. Seasonal changes dictate the kind of clothes that people wear and the corresponding weight and properties of the fabrics chosen.

You may want to consider your own wardrobe as a starting point in learning to recognize seasonal changes, styles, and differences in fabrics. Heavier-weight fabrics (such as wool tweed) tend to be worn as outerwear garments, while hard-wearing fabrics (such as denims and corduroy) tend to be good for trousers, shorts, and jackets. The summer months require lighter fabrics (such as cotton lawn, crêpe de chine and cotton).

WEIGHT AND STABILITY

The stability and weight of certain fabrics naturally lend themselves to given types of clothing design. A soft, transparent chiffon, for example, is suited to a layered approach with minimal seamlines, but difficult to cut and sew.

Gabardine, on the other hand, has good stability and drape, and works well for tailored jackets, trousers and skirts. Woven tailored fabrics with a small percentage of Lycra stretch in them allow for extra comfort and better fit and are intended for skirts, trousers and jackets.

Research your fabrics after you have worked out the line-up for your capsule collection and your colour story. Buy or collect small swatches before purchasing reams of fabric. Place your swatches next to your designs and carefully consider which fabrics will make the garments. This is the stage where you can begin to create your "toiles" – the fashion industry equivalent of design prototypes – in calico (an inexpensive fabric that is easy to work with). Purchase your fabrics once you are happy with your toile and are able to determine just how much fabric length will be required for each garment. Use your toile to work through alterations and style adjustments, then transfer the information to your paper pattern pieces. Only then should you finally cut into the actual cloth.

GENERAL ADVICE

• Check the full length of the cloth for flaws before cutting out. It cannot be returned to the shop if you spot these after you have started cutting.

WOVEN FABRICS (MEDIUM WEIGHT)

These are probably the easiest to work with especially if they are stable—neither stretching nor slipping when being handled.

CALICO

DESCRIPTION: A coarse, unbleached, plain weave fabric made from cotton or a cotton blend, calico varies in quality but is generally unfinished and undyed. Inexpensive and creases badly.

APPLICATIONS: Its most popular use is for making toiles or garment prototypes to work out any corrections before cutting into the real fabric.

CASHMERE

DESCRIPTION: Cashmere fibres come from the fine, soft undercoat of the Kashmiri goat. It is used on its own or mixed with other fibres including silk, wool and cotton. It may be knitted or woven into fabric and produces a very soft, warm, luxurious cloth.

APPLICATIONS: Use woven cashmere for coats, jackets, skirts and scarves. Use knitted cashmere for sweaters, cardigans and dresses.

CHEESECLOTH

DESCRIPTION: Traditionally used to wrap cheese, this cotton cloth is loosely woven with a crinkled texture and a crêpe appearance.

APPLICATIONS: Cheesecloth was popular during the 1970s as casualwear for shirts, blouses and dresses.

USING WOVEN FABRICS (MEDIUM WEIGHT)

- Cut small pieces to experiment with washing, pressing and stitching techniques.

- Cut with sharp shears to give a smooth edge. Short scissors will give a ragged cut.

- Preshrink by steaming or washing if necessary.

- Iron fabric on the wrong side or use a pressing cloth to protect the surface.

CRÊPE-BACKED SATIN

DESCRIPTION: This has a softer hand than duchess satin with one smooth, lustrous side and a dull, crêpe side. Either or both sides can be used in a garment. Traditionally made from silk, it is now often made from synthetic fibres.

APPLICATIONS: Can be used for tops, blouses, dresses and shirts.

DAMASK

DESCRIPTION: Damask refers to the pattern created in the weave by a jacquard loom. The resulting fabric can be made from various fibres including silk, cotton, linen and blends. The pattern is in a single colour on the surface of the fabric.

APPLICATIONS: Use for dresses, jackets, trousers and skirts. Traditionally, damask weaves were widely used for table linens.

DUCHESS SATIN

DESCRIPTION: Made from silk or synthetic fibres, duchess satin has a beautiful shiny appearance as a result of the many surface threads created by the satin weave. It is a heavier weight than satins used for lingerie and linings, but is just as lustrous and slippery to work with.

APPLICATIONS: Use for wedding gowns and evening dresses, handbags and clutch bags. Lighter weights can be used for shirts and dresses.

FLANNEL

DESCRIPTION: A durable fabric that is made from cotton or wool fibres in a plain or twill weave, the surface of flannel is normally brushed or napped on one or both sides.

APPLICATIONS: Can be used for bedding, pyjamas and nightdresses as the napped surface makes them feel warm.

GABARDINE

DESCRIPTION: A firm, closely woven fabric made from worsted wool, cotton, synthetic or mixed fibres, gabardine is woven in a twill weave giving diagonal ribs on the surface of the cloth. It drapes well and does not wrinkle.

APPLICATIONS: Best used for tailored garments like jackets, trousers, skirts and coats.

HEMP

DESCRIPTION: This fabric comes from the stems of the *Cannabis sativa* plant which are processed to release the fibres. The resulting yarns are woven into a strong, coarse cloth that looks and handles much like linen.

APPLICATIONS: Use for jackets, trousers, shirts, skirts and dresses.

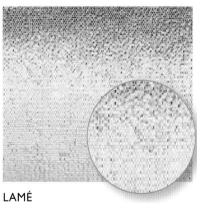

LAMÉ

DESCRIPTION: Either woven or knitted from metallic threads, lamé has a luxurious, glittery appearance but does tend to unravel.

APPLICATIONS: Use for evening and partywear, dresses, skirts and tops.

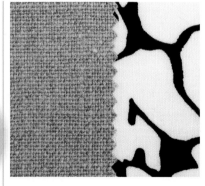

LINEN

DESCRIPTION: Linen fabric is made from the stems of the flax plant. The stems are processed to release the fibres and the resulting yarns are woven into a strong, crisp cloth. The fabric can be woven in plain, twill and damask weaves and ranges from very lightweight handkerchief linen through to medium weights for clothing and heavier weights for outerwear. It wrinkles badly but is extremely absorbent and strong.

APPLICATIONS: Depending on the weight, use for blouses and shirts or jackets, trousers and coats.

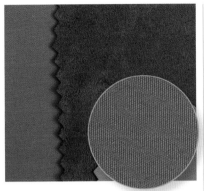

MICROFIBRE

DESCRIPTION: Microfibre is an extremely fine synthetic fibre filament. It's suitable for fine fabric and heavier weights. The strong yarns are able to withstand different types of treatments and so create a variety of finishes, including suede and sand finishing. It drapes well and does not cling or crease.

APPLICATIONS: Suits soft, draping designs. Used for sportswear as it can be made to wick moisture away from the body.

POPLIN

DESCRIPTION: Generally made from cotton, poplin has a crossways ribbed texture on the surface due to heavier weft yarns. It is a strong, durable fabric which is easy to iron and does not wrinkle readily.

APPLICATIONS: Use for dresses, jackets, trousers and skirts.

RAW SILK (NOIL)

DESCRIPTION: Made from the shorter, poorer-quality silk fibres, raw silk is woven and has a dull surface finish. It frays badly.

APPLICATIONS: Use for jackets, shirts, skirts and dresses that are loose and not fitted.

SATEEN

DESCRIPTION: Sateen is a woven cotton cloth with a satin weave. The long surface threads reflect light as a dull shine. If the threads are mercerized this will strengthen them and improve their lustre.

APPLICATIONS: Good for shirts, dresses, children's clothing and traditional nightdresses and pyjamas.

TAFFETA

DESCRIPTION: A crisp, plain woven fabric with a surface sheen, taffeta is traditionally made from silk, although synthetic fibres are often used today. Sometimes the warp and weft threads are of different colours to give an iridescent effect. Taffeta does not drape due to its stiffness so choose styles to suit its crisp quality.

APPLICATIONS: Use for full-length evening gowns and partywear.

WORSTED WOOL

DESCRIPTION: A worsted yarn is one where long fibres have been combed and highly twisted for a smooth, strong finish. This yarn is then woven in a plain or twill weave to create a resilient fabric.

APPLICATIONS: Depending on the weight of the cloth, use for coats and jackets or dresses, trousers and skirts.

WOVEN FABRICS (HEAVYWEIGHT)

Since they are stiff or thick and bulky, heavyweight woven fabrics can be difficult to cut out and handle.

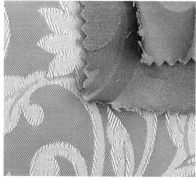

BOUCLÉ

DESCRIPTION: Bouclé refers to the surface texture of a fabric which has curled loops, of which there are many varieties. Bouclé yarn (normally wool) is curled and twisted, and creates a loopy texture when woven or knitted.

APPLICATIONS: Its novelty surface makes it suitable for simple sweaters, cardigans and jackets that have little detail.

BROCADE

DESCRIPTION: A crisp, bulky fabric with a surface design woven on a jacquard loom. The design on brocade is created by raised surface threads which give a pattern on both sides of the cloth. Metallic threads are often incorporated into the design.

APPLICATIONS: Good for elegant evening jackets and waistcoats.

CAMEL HAIR

DESCRIPTION: Soft and very warm, camel hair comes from the undercoat of the Bactrian camel. It can be used on its own or combined with other wool fibres and then woven or knitted to make cloth.

APPLICATIONS: Ideal for coats, jackets and scarves. Knitted camel hair can be made into sweaters and cardigans.

USING WOVEN FABRICS (HEAVYWEIGHT)

• Always use sharp, long-bladed scissors to give a smooth edge.

• If pins are not long enough use weights to secure pattern pieces.

• Cut in a single layer rather than folding the fabric if it is too thick.

• Use a larger machine needle (size 14/90 or above) and increase the stitch length.

• Reduce the pressure from the foot when sewing.

• A walking foot is sometimes helpful when sewing thick layers.

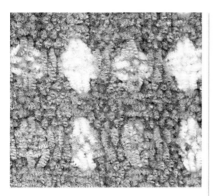

CHENILLE

DESCRIPTION: Chenille yarn has a velvety texture so the resulting cloth (which is normally knitted) has a soft, tufted pile. It is a thick and warm fabric made from wool, cotton or synthetic fibres.

APPLICATIONS: Popular for sweaters, cardigans and jackets.

CORDUROY

DESCRIPTION: A woven fabric recognized by the ridges which run the length of the cloth, corduroy can vary from fine needle cord to broader whale cord. Very strong and hardwearing, it is made from cotton; the pile surface gives it a nap.

APPLICATIONS: Good for jackets, trousers and skirts.

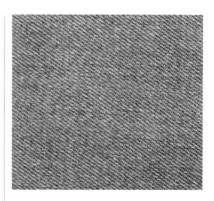

DENIM

DESCRIPTION: A very strong cotton fabric, denim is made in a twill weave that generally uses blue warp threads and white weft threads. Denim can be treated and softened without losing strength, making it suitable for a wide range of sewing projects.

APPLICATIONS: Use for jeans, casual jackets, straight skirts and bags. Shirts, dresses and softer skirt styles can be made from a lighter weight.

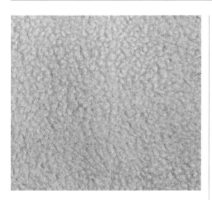

FLEECE

DESCRIPTION: Synthetic fleece provides warmth without weight and is a comfortable and durable fabric. It is often treated to give better finishing qualities, such as anti-pilling, and has been developed in a range of weights. It does not fray and has a degree of stretch due to its knitted construction.

APPLICATIONS: Thanks to its softness and depth, fleece is perfect for winter clothing with simple lines, such as jackets, leggings, hats and scarves.

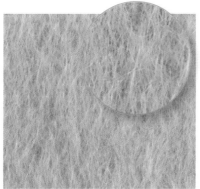

MOHAIR

DESCRIPTION: Mohair – derived from the Angora goat – is soft, silky and warm, producing a beautifully lustrous fabric. It is durable and resilient but due to the expense of the fibre is often blended with others.

APPLICATIONS: Good for jackets and coats.

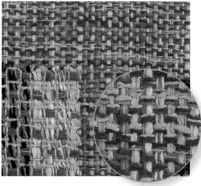

SILK TWEED

DESCRIPTION: A loosely woven cloth with a rough surface, silk tweed is made with yarns spun from shorter silk fibres. Like wool tweed, the pattern is created by the coloured woven threads. It is warm and comfortable to wear but often needs the support of an underlining to extend the life of a garment.

APPLICATIONS: Can be used for jackets and coats.

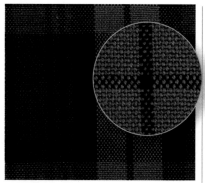

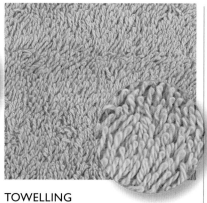

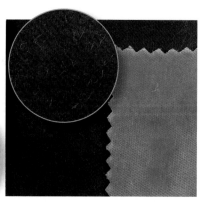

TARTAN

DESCRIPTION: In this traditional Scottish woollen cloth, the threads or yarns are dyed and then woven into cloth in bands of colour, making stripes along and across the fabric to create plaids or checks. Today, tartan can refer to the pattern and describes fabric made in various weights and fibres. Traditionally a length of tartan fabric was folded and worn as a kilt in Scotland.

APPLICATIONS: Use for skirts, dresses, trousers and jackets.

TOWELLING

DESCRIPTION: Towelling, or terry cloth, is a cotton fabric with loops on one or both sides. The increased surface area created by the loops makes it highly absorbent.

APPLICATIONS: Use for towels, dressing gowns and beachwear.

VELVET

DESCRIPTION: A woven fabric with a dense pile on one side, velvet is made by cutting the warp threads. Traditionally made from silk, today's velvet is usually made from cotton, polyester, viscose and acetate fibres, or mixtures of these. Cotton velvet is more forgiving and easier to handle.

APPLICATIONS: Use for jackets, skirts, eveningwear and special-occasion garments.

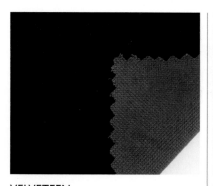

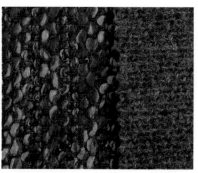

VELVETEEN

DESCRIPTION: Similar to velvet but made from cotton and cotton blends, the pile in velveteen is shorter and created by the weft threads. It is easier to work with than velvet but has a dull surface. It is more versatile than velvet for eveningwear, as it is more durable and easier to care for.

APPLICATIONS: Use for coats, jackets, skirts, children's clothes and bags.

WOOL TWEED

DESCRIPTION: A woven fabric traditionally made from coarse homespun wool, wool tweed is normally made from two or more colours of yarn creating checks or patterns. It is a warm fabric but its coarse texture is not comfortable next to the skin.

APPLICATIONS: Ideal for jackets, waistcoats and coats. It can be used for trousers or skirts but must be lined for comfort and to avoid losing its shape. Tweed handbags, men's scarves, and hats are also popular.

OPENWEAVE FABRICS

These include decorative, delicate, hand-finished fabrics with open weaves.

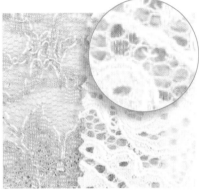

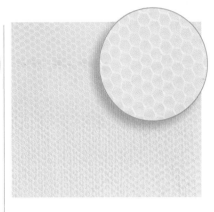

BRODERIE ANGLAIS

DESCRIPTION: This is a form of lace or cut-work with a pattern stitched on a lightweight white cotton background and small areas of the fabric removed. It does not need the same careful handling as many other laces.

APPLICATIONS: Use for shirts, blouses and lined dresses.

LACE

DESCRIPTION: Lace fabric is a fine, openwork cloth with a pattern or design. It can be made in many different ways with threads of silk, cotton or synthetic fibres. Some laces are hand crocheted with a hook and a single yarn, while others are embroidered threads or cords on a net background.

APPLICATIONS: Lace comes in many forms and its type will determine whether it is used for evening or bridal wear, lingerie and nightdresses. Edging lace may also be used to trim garments, or a lace collar may finish a neckline. Choose styles with the minimum of seams and detail so as not to detract from the lace.

NET AND TULLE

DESCRIPTION: Net is a mesh of threads making a crisp, light, openweave fabric. Tulle is generally a finer mesh with a slightly softer handle. Both can be made from synthetic fibres, although silk tulle makes beautiful bridal veiling. Net has a stiff quality, ideal for creating volume in a garment.

APPLICATIONS: Net is frequently used as an underlining to create body without weight to a full skirt. It is also used for underskirts. Tulle is more often used for veils or in multiple layers to make softly floating bridal and evening skirts.

USING OPENWEAVE FABRICS

• Take time to study the pattern before cutting out.

• Cut off small swatches and experiment with washing, ironing and stitching.

• Iron from the wrong side or use a pressing cloth to protect the surface.

• Use a dry iron unless confident that water marks will not remain.

• Unstable or delicate fabrics should be placed in a single layer of cotton fabric for cutting out, to prevent the fabric distorting.

SHEER FABRICS

Made from natural or synthetic fibres and described as fine, lightweight, soft, or crisp, sheer fabrics are delicate and often need careful handling.

CHIFFON

DESCRIPTION: A fine, sheer fabric with a soft, open weave, it has a floating quality and drapes nicely. It is generally made from synthetic fibres, but silk chiffon can be used for special-occasion wear.

APPLICATIONS: Use it for simple-shaped styles with minimal seams, such as gathered skirts, loose tops, and dresses. It is often used as an overlayer for fabric that is less sheer.

COTTON CAMBRIC

DESCRIPTION: Similar to lawn and organdie, batiste is a soft, fine, lightweight fabric woven in a plain weave. It can also be made from wool or polyester fibres and is sometimes called batiste.

APPLICATIONS: Can be used for dresses, blouses, shirts and skirts.

COTTON LAWN

DESCRIPTION: A fine, smooth plain weave fabric similar to organdie and batiste, cotton lawn has a soft crisp finish and absorbs moisture as it is made from natural fibres. Comfortable to wear.

APPLICATIONS: Use for dresses, blouses and lightweight skirts.

GEORGETTE

DESCRIPTION: A lightweight silk fabric similar to chiffon with a dull crêpe surface texture, georgette is highly twisted with more body and stiffness than would be expected for its weight.

APPLICATIONS: Can be used for loose-fitting blouses, shirts, dresses and gathered skirts.

LINING

DESCRIPTION: Similar in that they are lightweight, thin and have a slippery surface, lining fabrics can be made from silk fibres (habotai) or synthetic fibres. The weave can be plain or satin.

APPLICATIONS: Jackets, coats, dresses, skirts, trousers and handbags are all lined to enclose the raw edges within. In the case of clothing, linings make slipping the garments on and off easier.

MUSLIN

DESCRIPTION: A loosely woven, plain weave cotton cloth, muslin is unbleached or white in colour and comes in various weights. The best quality is made from strong fine woven yarns while cheaper muslin is thinner and sized to add stiffness (this washes out).

APPLICATIONS: Use for blouses and dresses, lining it where necessary.

ORGANDIE

DESCRIPTION: A sheer, crisp plain weave cloth originating in Switzerland. Organdie is made from very fine cotton yarns woven to produce a smooth and fine fabric. It creases badly but some modern finishes can help to prevent this.

APPLICATIONS: Use for making blouses or shirts. The crispness of the fabric makes some styles more suitable than others.

SILK HABOTAI

DESCRIPTION: A very soft, fine silk in a smooth, plain weave, habotai drapes softly but can cling to the body. It is used for linings, lingerie and nightwear.

APPLICATIONS: Use silk habotai for lining. As it is soft and made from a natural fibre it absorbs moisture which makes it comfortable next to the skin. For the same reason, silk habotai is used for camisoles, nightdresses and dressing gowns.

THAI SILK

DESCRIPTION: A lightweight plain weave fabric with an uneven surface created by slubs in the weft threads. Thai silk has a lustrous surface and it's appearance can change depending on the light reflecting off its surface. It is therefore necessary to cut out all pattern pieces in the same direction to avoid differences in colour.

APPLICATIONS: Use for eveningwear, tops and dresses.

VOILE

DESCRIPTION: Similar to cotton lawn and organdie, this sheer, transparent fabric is both thin and light. It is a plain weave fabric made with highly spun yarns giving it a soft crispness. It is made from cotton or synthetic fibres and can be plain or printed.

APPLICATIONS: Use for blouses and dresses, lining it where necessary.

USING SHEER FABRICS

• Cut out with sharp shears to give a smooth edge.

• Use a rotary cutter for small pattern pieces as light fabric tends to shift less.

• Use bridal pins and place them in the seam allowance to limit damage to the fabric.

• Use a fine, standard or Microtex needle for sewing.

• Use machine embroidery thread if necessary as it is very fine.

• You will find a crisp textured fabric will be easier to work with than a softer one.

• For straight stitch, use a straight-stitch sole plate. This prevents the fabric from being pushed down into the body of the machine.

• Do not start sewing a fine fabric on the edge. Start just in from the edge to avoid the fabric being pushed down into the body of the machine.

• Pull gently in front of and behind the needle when stitching to eliminate puckering.

• Wind the bobbins slowly. Fast-wound bobbins are taut and can cause seams to pucker.

STRETCH FABRICS

These fabrics stretch slightly or extensively, across the cloth, or both across and lengthways. They are often knitted in construction to allow the fabric flexibility when pulled but it is also possible for woven fabrics to stretch due to the addition of Lycra. Some garment designs require stretch in both directions while others need stability coupled with stretch in only one direction.

ALL-OVER STRETCH LACE

DESCRIPTION: This fabric can be made from blends of synthetic and elasticated threads in a knitted lace construction.

APPLICATIONS: For lingerie and underwear use all-over stretch lace on its own or combined with other fabrics. Stretch lace can also be used for eveningwear.

COTTON JERSEY

DESCRIPTION: This lightweight knitted cloth is often used to make T-shirts. The knitted construction and cotton fibre enables it to stretch and makes it comfortable. It has a smooth surface and drapes well.

APPLICATIONS: Use for sweatshirts, loose trousers, and casual zip-up jackets.

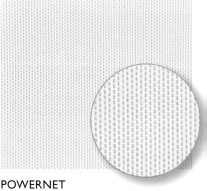

POWERNET

DESCRIPTION: Powernet is made with a high proportion of elastane, giving it excellent four-way stretch and recovery.

APPLICATIONS: Use for sweatshirts, loose sports trousers and casual zip-up jackets. This fabric is suited to loose-fitted garments that can be pulled on and off without the need for fastenings.

SLINKY KNIT (KNITTED SYNTHETIC FABRIC)

DESCRIPTION: This knitted two-way stretch fabric is made from synthetic fibres mixed with elastane (Lycra). Drapes beautifully and avoids wrinkling.

APPLICATIONS: Simple-shaped dresses, skirts and tops will benefit from the drape of the comfortable fabric.

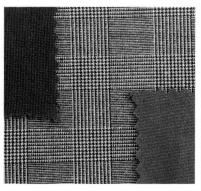

ELASTANE

DESCRIPTION: A modern synthetic fibre with great stretch and recovery, elastane is blended with other fibres to make fabrics requiring stretch properties. It is also used in suiting to retain shape.

APPLICATIONS: Use for sportswear, dancewear and underwear. Also used in fabrics for more tailored garments.

SWEATSHIRT FABRIC

DESCRIPTION: Also known as jersey cotton, this heavyweight knitted fabric has a smooth plain knit surface on the right side and a brushed surface on the wrong side. It is warm and comfy.

APPLICATIONS: Use for sweatshirts, loose sports trousers and casual zip-up jackets.

VELOUR

DESCRIPTION: The knitted equivalent of velvet, velour has a thick soft pile with a surface sheen. It looks like velvet but has more drape due to its knitted construction.

APPLICATIONS: Use for simple-shaped dresses, skirts and tops which will benefit from the drape of the fabric.

WOOLLEN JERSEY

DESCRIPTION: Woollen jersey is a fairly thick knitted fabric made from wool or wool blends. It can be hand-knitted or constructed on a machine with a similar appearance.

APPLICATIONS: Can be used for sweaters, cardigans or loose-fitting casual jackets.

USING STRETCH FABRICS

• Check if the pattern requires one-way or two-way stretch for the design to work.

• Pull the fabric to see how much it stretches and how well it recovers its shape.

• Check that the fabric is not twisted before cutting into it.

• Place the pattern pieces in the direction of stretch required.

• Use stretch needles or ballpoint needles as these slip between the threads rather than splitting them.

• Polyester thread has a slight "give" and works well for most stretch fabrics.

• Cut small pieces of fabric and experiment by washing, ironing and stitching them.

• Overlockers cope well with stretch due to the differential feed. If using a sewing machine, a walking foot helps to avoid any rippling which would otherwise occur.

RESOURCES

FASHION DESIGN COURSES

The following list comprises only a very small selection of the many colleges and universities worldwide with departments of fashion design. Whether you are looking for an evening class or for a full-time schedule in an undergraduate or postgraduate degree program, the huge variety of options available should mean that you will have no problem in finding the course that's right for you.

AUSTRALIA

Royal Melbourne Institute of Technology
GPO. Box 2476V
Melbourne
Victoria 3001
t.: (+61) 3 9925 2000
www.rmit.edu.au

CANADA

Montreal Superior Fashion School
La Salle College
2000 Ste-Catherine St. W.
Montreal
Quebec H3H 2T2
t.: (+1) 514 939 2006
www.collegelasalle.com

DENMARK

Copenhagen Academy of
Fashion Design
Nørrebrogade 45, 1. sal
2200 Copenhagen N.
t.: (+45) 33 328 810
www.modeogdesignskolen.dk

FRANCE

Creapole
128 r. de Rivoli
75001 Paris
t.: (+33) 1 4488 2020
www.creapole.fr

Esmod Paris
16 blvd Montmartre
75009 Paris
t.: (+33) 1 4483 8150
www.esmod.com

Parsons Paris
14 r. Letellier
75015 Paris
t.: (+33) 1 4577 3966
www.parsons-paris.pair.com

ITALY

Domus Academy
Via Watt 27
20143 Milano
t.: (+39) 24241 4001
www.domusacademy.it

Polimoda
via Pisana 77 1-50143
Firenze
t.: (+39) 55 739 961
www.polimoda.com

NETHERLANDS

Amsterdam Fashion Institute
Mauritskade 11
1091 GC Amsterdam
t.: (+31) 20 592 55 55
www.amfi.hva.nl

SPAIN

Institucion Artistica de
Ense-anza
c. Claudio Coello 48
28001 Madrid
t.: (+34) 91 577 17 28
www.iade.es

U.K.

University of Brighton
Mithras House
Lewes Road
Brighton BN2 4AT
t.: (+44) (0)1273 600 900
www.brighton.ac.uk

Central St Martin's College of
Art and Design
107 Charing Cross Road
London WC2H 0DU
t.: (+44) (0)20 7514 7000
www.csm.arts.ac.uk

De Montfort University
The Gateway
Leicester LE1 9BH
t.: (+44) (0)116 255 1551
www.dmu.ac.uk

East London University
Docklands Campus
4–6 University Way
London E16 2RD
t.: (+44) (0)20 8223 3405
www.uel.ac.uk

Kingston University
River House
53–57 High Street
Surrey KT1 1LQ
t.: (+44) (0)20 8547 2000
www.kingston.ac.uk

London College of Fashion
20 John Prince's St.
London W1G 0BJ
t.: (+44) (0)20 7514 7344
www.fashion.arts.ac.uk

University of Manchester Institute of
Science and Technology
PO Box 88
Manchester M60 1QD
t.: (+44) (0)161 236 3311
www.manchester.ac.uk

Middlesex University
Cat Hill Campus
Chase Side
Barnet
Herts, EN4 8HT
t.: (+44) (0)20 8411 5555
www.mdx.ac.uk

Nottingham Trent University
Burton St.
Nottingham NG1 4BU
t.: (+44) (0)115 941 8418
www.ntu.ac.uk

Ravensbourne College of
Design and Communication
Walden Road
Chislehurst
Kent BR7 5SN
t.: (+44) (0)20 8289 4900
www.ravensbourne.ac.uk

Royal College of Art
Kensington Gore
London SW7 2EU
t.: (+44) (0)20 7590 4444
www.rca.ac.uk

University College
for the Creative Arts
Ashley Road
Epsom
Surry KT18 5BE
t.: (+44) (0)1372 728 811
www.ucreative.ac.uk

University of Westminster
Harrow Campus
Northwick Park
Harrow HA1 3TP
t.: (+44) (0)7911 5000
www.westminsterfashion.com

U.S.A.

American Intercontinental University
(Buckhead)
3330 Peachtree Rd, N.E.
Atlanta, GA 30326
t.: (+1) 888 591 7888
www.aiubuckhead.com

American Intercontinental University
(Los Angeles)
12655 W. Jefferson Blvd
Los Angeles, CA 90066
t.: (+1) 800 421 3775
www.aiula.com

Brooks College of Fashion
4825 E. Pacific Coast Hwy
Long Beach, CA 90804
t.: (+1) 800 421 3775
www.brookscollege.edu

Cornell University
170 Martha Van Rensselaer Hall
Ithaca, NY 14853
t.: (+1) 607 254 4636
www.cornell.edu

Fashion Careers of California College
1923 Morena Blvd
San Diego, CA 92110
t.: (+1) 619 275 4700
www.fashioncareerscollege.com

Fashion Institute of Design and
Merchandising (Los Angeles)
919 S. Grand Ave.
Los Angeles, CA 90015-1421
t.: (+1) 800 624 1200
www.fidm.com

Fashion Institute of Design and
Merchandising (San Diego)
1010 2nd Ave.
San Diego, CA 92101-4903
t.: (+1) 619 235 2049
www.fidm.com

Fashion Institute of Design and
Merchandising (San Francisco)
55 Stockton St.
San Francisco, CA 94108-5829
t.: (+1) 415 675 5200
www.fidm.com

Fashion Institute of Design and
Merchandising (Orange County)
17590 Gillette Ave.
Irvine, CA 92614-5610
t.: (+1) 949 851 6200
www.fidm.com

Fashion Institute of Technology
Seventh Ave. 27 St.
New York, NY 10001
t.: (+1) 212 217 7999
www.fitnyc.edu

International Academy of
Design and Technology
(Chicago)
1 N. State St., Suite 400
Chicago, IL 60602
t.: (+1) 312 980 9200
www.iadtchicago.edu

International Academy of
Design and Technology
(Tampa)
5225 Memorial Hwy
Tampa, FL 33634
t.: (+1) 888 315 6111
www.academy.edu

Katherine Gibbs School
50 W. 40th St.
New York, NY 10138
t.: (+1) 212 867 9300
www.gibbsny.edu

Parsons School of Design
66 Fifth Ave., 7th Floor
New York, NY 10011
t.: (+1) 212 229 8590
www.parsons.edu

School of Fashion Design
136 Newbury St.
Boston, MA 02116
t.: (+1) 617 536 9343
www.schooloffashiondesign.org

University of North Texas School of
Visual Arts
Office of Undergraduate Admissions
PO Box 305100
Denton, TX 76203-5100
t.: (+1) 940 565 2855
www.art.unt.edu

FASHION DESIGNERS ONLINE

If you are stuck for inspiration or want to bring yourself up to date on forthcoming trends, why not check out the websites belonging to the top fashion designers? Here are just some of the good sites:

www.agnesb.fr
www.alexandermcqueen.com
www.annasui.com
www.antoniandalison.co.uk
www.apc.fr
www.balenciaga.net
www.betseyjohnson.com
www.bless-service.de
www.bruunsbazaar.com
www.burberry.com
www.celine.com
www.cerruti.com
www.chanel.com
www.christian-lacroix.fr
www.coupny.com
www.daniellenault.com
www.delphinepariente.fr
www.dior.com
www.dolcegabbana.it
www.donnakaran.com
www.driesvannoten.be
www.elspethgibson.com
www.emiliopucci.com
www.fendi.it
www.ghost.co.uk
www.gianfrancoferre.com
www.giorgioarmani.com
www.giovannivalentino.com
www.givenchy.com
www.gucci.com
www.helmutlang.com
www.hugo.com
www.isseymiyake.com
www.jaeger-lecoultre.com

www.jaredgold.com
www.jasperconran.com
www.jeanmuir.co.uk
www.johngalliano.com
www.jpgaultier.fr
www.karenwalker.com
www.katespade.com
www.kennethcole.com
www.kenzo.com
www.lacoste.com
www.lloydklein.com
www.lucienpellat-finet.com
www.marcjacobs.com
www.michaelkors.com
www.moschino.it
www.oscardelarenta.com
www.pacorabanne.com
www.patriciafield.com
www.paulsmith.co.uk
www.peopleusedtodream.com
www.pleatsplease.com
www.polo.com
www.prada.com
www.redblu.com
www.robertocavalli.it
www.seanjohn.com
www.soniarykiel.com
www.stellamccartney.com
www.tommy.com
www.versace.com
www.viviennewestwood.com
www.vuitton.com
www.yohjiyamamoto.co.jp
www.ysl.com

INDEX

A

A-line 28
adjustable hem 113
adjustable sleeve 41
adjustable-tab
 waist-band 76, 81
"Age of Opulence"
 26
all-in-one cut away
 53
all-over stretch lace
 137
androgynous look
 28
asymmetric collar
 56
asymmetric hem
 113, 115, 119, 121

B

band collar 56
banded halterneck
 67
banded hem 115,
 119
banded waistband
 83
batiste 134
batwing sleeve 41,
 51
bell sleeve 41
bellows pocket 85,
 87, 91, 93
belted cuff 94
belt fastening 107,
 109, 111
belted waistband
 77, 79, 81
Bertha collar 56, 65
biker's leathers: as
 inspiration 34-7
bishop collar 56
bishop sleeve 41, 47

dropped-shoulder
 51
blouses:
 collars 62-3
 cuffs 98-9
 fastenings 108-9
 necklines 62-3
boat-neck 55, 65,
 67, 69, 71
bouclé 132
bound cuff 94, 99
bow 105, 107
bow collar 56, 65
braces 104
brocade 131
broderie anglaise
 133
buckle 105
buckle waistband 77
bustle 26
butcher's apron: as
 inspiration 14-15
button tab closure
 104
button tab cuff 94,
 97
button-front
 standing collar 59
button-up collar 59
buttons 105, 107,
 109

C

calico 127
camel hair 132
cape sleeve 45
capped sleeve 41,
 49, 53
cargo pocket 85, 91
cashmere 128
Chanel, Coco 27
cheesecloth 127
chenille 132
chiffon 135

childhood: as theme
 16, 18
 coats:
 cuffs 96-7
 fastenings 106-7
 hems 114-15
 pockets 86-7
 sleeves 42-5
collar and placket
 65, 69
collar and revere
 57, 61, 75
collar without stand
 59, 61
collars 54-75
 blouse 62-3
 dress 70-1
 high 28
 jacket 58-61
 knitwear 72-5
 necklines 58-61
 shirt 62-3
 tops 64-9
colour story 32-3
colours:
 affect on
 appearance 33
 choosing 30-1
 chromatic balance
 33
 combinations 30
 contrasting 31
 meaning of 30, 31
 neutrals 31
 power of 30
 seasonal 31
 testing in scale 33
corduroy 130
corsets: styles using
 26
cotton cambric 134
cotton jersey 136
cotton lawn 134

crêpe-backed satin
 128
crew neck 57, 65
cuffed hem 117
cuffs 94-103
 blouse 98-9
 coat 96-7
 jacket 96-7
 knitwear 102-3
 shirt 98-9
 top 100-1
curved and ticket
 pocket 85
curved hem 113
curved jet pocket
 84
curved pocket 85,
 91
curved waist 76, 83
curved-rib hem 123
cut-away shoulder
 sleeve 40, 51

D

D-rings 104
damask 127
décolletage 54, 67
denim 131
design:
 development
 18-19
Dior, Christian 28
disco: as inspiration
 29
dolman sleeve 41,
 47, 49, 51
double cuff 95
drape neckline 55
drapes: testing on
 dress form 20-3
drawstring closure
 105
drawstring hem
 113, 115

drawstring neckline
 55
drawstring
 waistband 77, 81,
 83
dress stand:
 shapes 23
 working on 20-3
dresses:
 collars 70-1
 hems 120-1
 necklines 70-1
 sleeves 50-1
dropped shoulder
 sleeve 40, 43, 45,
 49, 51
duchess satin 128

E

elastane 136
elasticated cuff 94,
 97
elasticated
 waistband 77, 81,
 83
empire waistline 76
envelope neckline
 55
equestrian themes
 15, 19

F

fabrics 126-37
 getting to know:
 using dress stand
 20-3
 openweave 133
 seasonal changes
 126
 sheer 134-5
 stability 126
 stretch 136-7
 weight 126
 woven:

heavyweight 130-2
medium weight
127-9
faced hem cuff 95,
97, 101
faced waistband
76, 83
fastenings104-11
blouse 108-9
coat 106-7
jacket 106-7
shirt 108-9
short 110-11
trouser 110-11
feet: reducing size
26
female form:
proportions 24-5
reference points
24
waist positions 25
figures: templates
25
fitted cuff 95, 99,
101, 103
flannel 129
flap pocket 89, 91
flared hem 117
flared sleeve 45
fleece 131
fluted sleeve 41
frill collar/neck 57,
63, 69
oversized box frills
71
frill cuff 94, 99, 101
frill hem 113, 115,
117
frill sleeves 40, 49,
51
double-layer 53
fringed hem 113,
119
frog 104, 107
front tab waistband
77, 79, 81
front-slit hem 117

funnel neckline 55

G
gabardine 129
Galliano, John 14
"la garconne"
silhouette 27
garments: lengths
24, 25
gathered collar 63
gathered cuff 103
gathered sleeve
with cuff 51
georgette 135
grown on collar 61

H
halterneck 55, 71
banded 67, 71
handkerchief hem
113
hats/headdress:
cartwheel 27
cloche 27
elaborate 26
hemp 129
hems 112-23
coat 114-15
dress 120-1
jacket 114-15
shorts 116-17
skirt 118-19
trouser 116-17
Henley collar 57
high waist 76
hipsters 76
hobble skirts 27
hood collar 57, 75
hook and bar 104
hook and eye 104
horseshoe neckline
55
hour-glass figure 26

I
insert frill hem 113,
115, 117, 121

asymmetric 119
inset neckline 54
inspiration 14-15

J
jackets:
cuffs 96-7
fastenings 106-7
hems 114-15
pockets 86-7
sleeves 42-5
jersey:
cotton 136
woollen 136
jet with zip
pocket 85
jet/button pocket
84
jet/flap pocket 84
jet/reinforcement
pocket 84
jet/tab pocket 84

K
kangaroo pocket 85
Kennedy, Jackie 28
keyhole cuff 94
with ties 101
keyhole neckline
55, 73
kimono sleeve 41,
49
Klein, Calvin 14
knitwear:
collars 72-5
cuffs 102-3
hems 122-3
necklines 72-5
sleeves 52-3

L
lace 133
all-over stretch 137
lace-up fastening
105, 111
laced cuff 95
laced waistband 77

lamé 128
lawn 134
layered hem 112,
119, 121
leg-of-mutton
sleeve 41
lengths: names 24,
25
linen 129
lining fabric 135
low waist 76, 79

M
"Make do and
mend" 28
mandarin collar 56,
59
medium waist 76
microfibre 129
military silhouette 28
Miyake, Issey 14
mohair 132
Monroe, Marilyn 76
moodboards 16-17,
32
developing ideas
from 18-19
motorcycle outfit:
as inspiration 34-7
multi-collar 63, 69
muslin 134

N
necklines 54-75
blouse 62-3
coat 58-61
dress 70-1
jacket 58-61
knitwear 72-5
shirt 62-3
tops 64-9
net 133
noil 127

O
off-the-shoulder
neckline 73

collared 63
organdie 134
organic neckline 71
oversized cuff 97

P
paper bag
waistband 77,
79, 81
patch pocket 85, 93
double 85
with flap 85, 91
patch/jet pocket
85
Patou, Jean 27
peplum waist 77
Peter Pan collar 57,
61, 73
pin-tuck hem 121
placket cuff 95
pleated hem 113
pleated slit sleeve
45
pockets 84-93
blouse 88-9
coat 86-7
jacket 86-7
shirt 88-9
shorts 90-1
skirt 92-3
trouser 90-1
Poirot, Paul 27
polo collar 57
poplin 127
poppers 104, 107
powernet 136
presentation sheet
32, 36
proportions 24-5
puffball hem 121
puffed sleeve 41, 49
exaggerated 53
punk rock 29

R
raglan sleeve 40,
45, 53

raw silk 127
research 14-15
ribbed collar 75
ribbed cuff 95, 103
ribbed hem 113, 117, 123
ribbed waistband 77
roll collar: open-neck 65
roll-neck 57, 65
romance: as theme of moodboard 17
rouleau loops 105
round neck 55, 63, 67, 69, 73
 collared 71
rounded-flap pocket 91
ruffles 56

S
S-shaped silhouette 26
saddle sleeve 40, 47, 51
sateen 128
satin:
 crepe-backed 128
 duchess 128
scale: testing colour in 33
scalloped hem 113, 123
scoop-neck 55, 67
set-in sleeve 40, 43, 47, 51
 with gathers 53
side-slit 51
shape:
 learning about: using dress stand 20-3
silhouettes 26-9
shaped waistband 77
shawl collar 57, 59, 75

shirt collar 57, 59, 63
 with placket 69
shirt cuff 99, 101
shirts:
 collars 62-3
 cuffs 98-9
 fastening 108-9
 necklines 62-3
shorts:
 fastenings 110-11
 hems 116-17
 pockets 90-1
 waistbands 78-81
shoulders:
 narrow 27, 29
 wide 29
side-slit set-in sleeve 51
side-seam pocket 87, 93
side-slit hem 121
silhouettes: shapes 26-9
silk:
 raw 127
 Thai 135
silk habotai 134
silk tweed 131
single cuff 95
single-vented hem 112
skating skirt 27
sketchbook 15
skirts:
 A-line 28
 calf-length 27
 flared 27
 hems 118-19
 knee-length 28
 lengths 24, 25
 mini 28
 pockets 92-3
 waistbands 82-3
slant pocket 85, 91
slash neckline 55
sleeveless style 40

sleeves 40-53
 coat 42-5
 dress 50-1
 jacket 42-5
 knitwear 52-3
 tops 46-9
slinky knit 137
slit sleeve 41, 43, 45
space travel: as inspiration: fabrics 19
square neck 54, 71, 73
stand collar 57, 61
 button-front 59
sweatshirt fabric 136
sweetheart neckline 54, 71

T
tab waistband 77, 79, 81
taffeta 128
tartan 131
tassel 105
textile board 20, 34
textiles see fabrics
Thai silk 135
tied front closure 109
tied waistband 83
toggle 105
tops:
 collars 64-9
 cuffs 100-1
 long sleeves 46-7
 necklines 64-9
 short sleeves 48-9
 sleeveless 48-9
topstitch binding hem 113, 119
towelling 132
trademark looks 14
tram-lined cuff 95
trousers:
 design: using

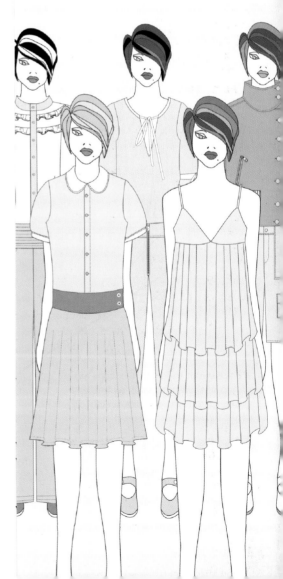

FOLD OUT THIS FLAP
FOR THE OUTLINE
FIGURE…

…AND USE HER TO DESIGN
YOUR PROTOTYPE FASHION
COLLECTION.

CREDITS
The editors would like to thank and acknowledge the following designers for images reproduced in this book:

FROM LONDON FASHION WEEK, FEBRUARY 2007:

Bora Aksu
Nicole Farhi
Gardem
Betty Jackson
Jens Laugesen

FROM FALL 2007 READY-TO-WEAR CENTRAL ST MARTINS RUNWAY FASHION SHOW, LONDON, FEBRUARY 2007:

Pavel Ivancic
Karmen Pedaru
Dasha V.
Annalisa Dunn
Kryzsztof Strozyna
Jamie Bruski Tetsill
Alexandra Agoston
Carolina Bergstein
Anna Schmidt Risak
Julia Hederus
Kumiko Watari
Scott Ramsay Kyle
Tessa Birch
Seon Ju Kam
Mattijis Van Bergen
Tatiana Katinova
Louise Gray
Chemena Kamali
Maria Francesca Pepe

FROM GRADUATE FASHION WEEK GALA SHOW, LONDON, JUNE 2007:

Alexis Gane
Charlie Ross
Clare Rondel
David Mattsson
Duncan Shaw
Gareth Williams
Gemma Leakey
Hannah Lidle
Jasper Chadprajong
Jessica Clarke
Julia Ison-Steirer
Kate Atkinson
Kelly Shaw
Kirsten Bridgewater
Krelsmata Elidom
Lilli Rose Wicks
Luis Lopez-Smith
Ming Lei Liu
Nicolas Thomas
Orsolya Szabo
Sara Nowell
Sarah Edwards
Sarah Ormannoyd
Tanveer Ahmed
Victoria Moore
Zoe Donald
Zoe Wilson-Foster

FROM LONDON COLLEGE OF FASHION CENTENARY M.A. SHOW, JANUARY 2007:

Zhang Ying (Joy Cheung)
Chloe Hewett
Yoni Pai

A special thanks to the students of London College of Fashion, Central St. Martins and Middlesex University, who kindly allowed us to reproduce their work in this book:

Yerkezhan Ashimova, Nicolas Clarke Aburn, Lova Mollar, Crimson-Rose O'Shea, Alex Rosenwald, Fannie Schlavoni, Caroline Wilkinson and Tracy Wong.

All other illustrations and photographs are the copyright of Quarto Publishing plc. While every effort has been made to credit contributors, the publisher would like to apologize should there have been any omissions or errors – and would be pleased to make the appropriate correction for future editions of the book.